ideals®
EASTER

Easter and springtime go hand in hand
at this happiest time of the year;
both bring a welcome to bright, pleasant days
where flowers and blossoms appear.

—GARNETT ANN SCHULTZ

ideals®

NASHVILLE, TENNESSEE

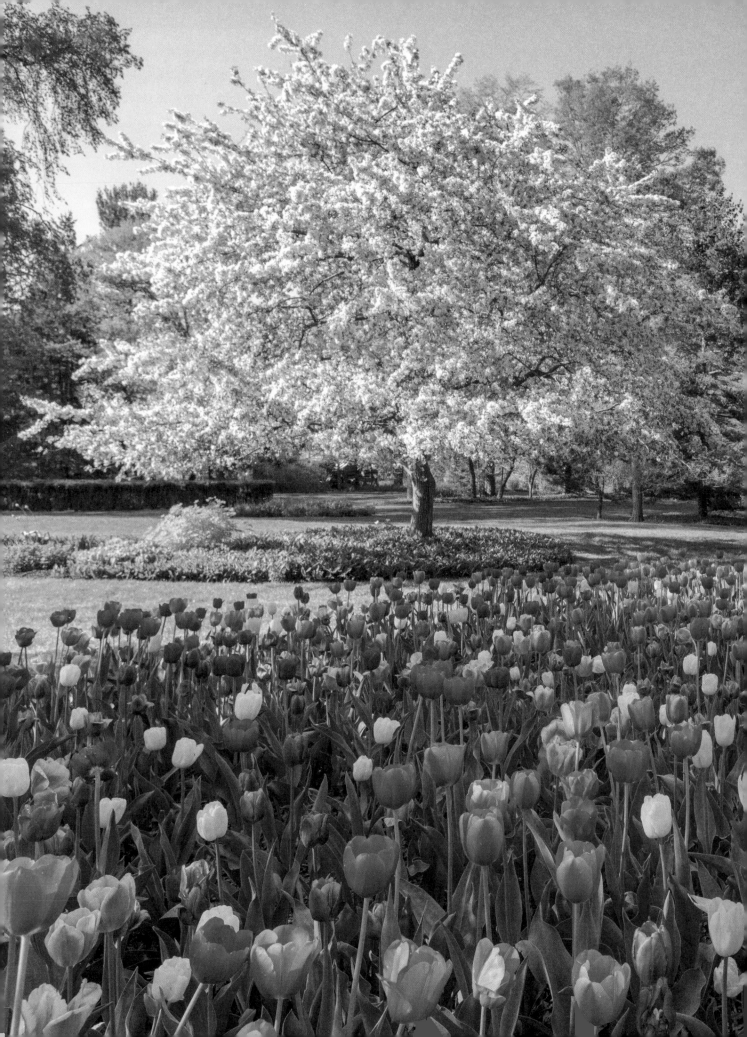

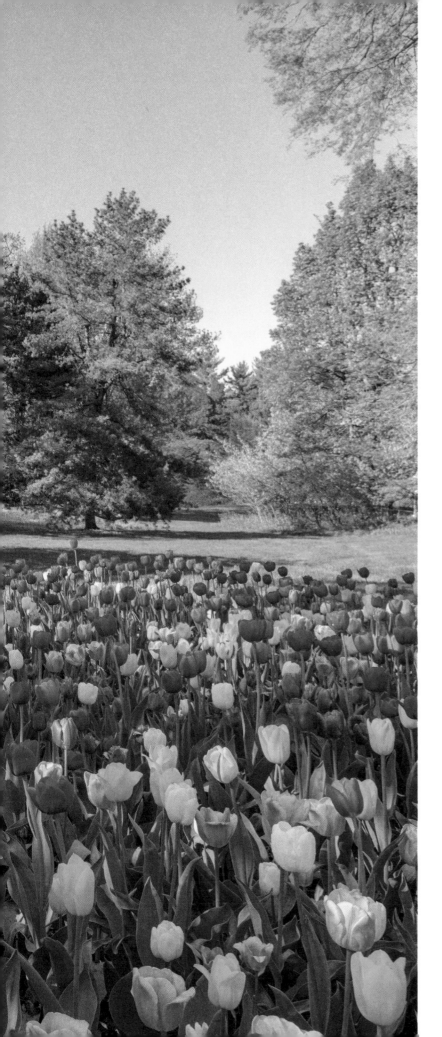

Spring
Eliza Cook

Welcome, all hail to thee!
Welcome, young Spring!
Thy sun-ray is bright
on the butterfly's wing.
Beauty shines forth
in the blossom-robed trees;
perfume floats by
on the soft southern breeze.

Time Enough
Eileen Spinelli

Uncapping her pen,
the poet begins
to write a poem of spring.

How to describe
the breeze that sways
the backyard swing?

How to capture the sky?
A sail of blue?
For grass and trees,
some greening phrase anew?

Outside, the children dance
in lemony sun.
The poet caps her pen
to join the fun,

twirling barefoot
to the song of birds.
Later, there'll be
time enough for words.

Image © Craig Sterken/Shutterstock

Doing a New Thing

Anne Kennedy Brady

I am not a bug person. There are too many legs and not enough fur for my taste, and I once saw a movie about giant spiders from which I am still recovering. But as the mother of a curious four-year-old, I've known that it's only a matter of time before my fear gets challenged. And the other day, my son brought home a caterpillar.

He found the fuzzy yellow creature shimmying beside the freshly blooming hostas outside our building. It's now our pet, because Milo gazed at me with giant, sad eyes and announced, "She doesn't have a family!" And I am not a heartless monster, so we carefully scooped the caterpillar—"Edie"—into a spacious plastic container filled with leaves and twigs and bark, and poked holes in the top. Edie crawled around the perimeter of her new apartment, and we took her out to play throughout the day. But when we checked on her one last time before bed, we couldn't find her right away. We finally located her, motionless, under some chunks of bark held together by strands of wispy thread. After a bit a research, I discovered that this particular caterpillar would emerge as a moth only after several months of "pupating" (*eww*) in a cocoon made of silk threads and pieces *of its own skin*. For heaven's sake.

Sipping my coffee on our front porch this morning and eyeing Edie's abode from a safe distance, I glimpse my husband making his way out to join me. Normally he'd be halfway into his commute by this time of day, but lately our morning routine has changed a bit. Now we spend a few minutes enjoying coffee and breakfast together, stealing a moment of calm before the demands of work and kids kick in. It has even given us the opportunity to get to know our neighbors better, as they walk their dogs or go jogging past our front porch.

Our daughter wakes up, and as I get her ready for the day, I remember anticipating her arrival. My primary concern was that my then three-year-old son would experience as little disruption as possible, as most of the parenting advice I was reading at the time emphasized how difficult a transition adding a sibling can be. I was panicked that he would resent his new sister. But all my planning couldn't prevent the inevitable schedule changes, forgotten school events, and hurried hot-dog-and-potato-chips dinners that accompany a newborn. And in spite of all that, after a few months of struggle and/or indifference, he turned to me one day and said, "Helen is the best Helen. And we have the best family." Now his love for Helen takes my breath away—and sometimes hers, as the line between snuggling and tackling is thinner than you might think.

During our afternoon walk, I take a closer look at the ways our neighborhood is waking up to a warm Chicago spring. There is a nest above our back porch light that now houses three loud

baby birds. Down the block, flowering weeds and tall grasses have overtaken a patch of earth from which a dead tree was removed last fall. Helicopter seeds cover the sidewalk, and Milo flings one into the air to watch it spin back to earth. He asks if all these seeds will become trees, and I explain that seeds need to be buried in dirt first. "I wouldn't want to be covered in the dirt," Milo asserts. "Me neither, buddy," I agree. "But that's the only way seeds can make new trees."

My thoughts drift back to that morning coffee with my husband. Our new friendship with our neighbors. Milo's goofy faces to get his sister to laugh at breakfast. The baby birds and the growing plants, and even Edie, sprouting wings or whatever inside that icky cocoon. It's clear the world already knows what I am just now naming: every new and beautiful thing is born of disruption. Spring grass emerges from winter snow. Seeds break open and eggs crack. Mornings look different. Baby sisters come home. Caterpillars shed their skin.

In Isaiah, God urges us to find joy in disruption: "Forget the former things; do not dwell on the past. See, I am doing a new thing!" (Isaiah 43:18–19a, NIV). I find a lot of comfort in the past, so disruption isn't usually something I seek out. Nevertheless, it finds me, just like it finds all of us. Sometimes it's easy to see the beauty in it. Falling in love and getting married is a disruption to be sure, but it was one I could pretty easily get behind. And having kids upset our apple cart in

the best possible way. But other times it's unwelcome, unplanned, and unsettling. Occasionally, it's something we never saw coming. But I think if I can stick around long enough to see the new things God is doing in the midst of it all, there might be real beauty on the other side. Like dandelions blooming in an empty patch of dirt. Like longer conversations, new laughter, deeper understanding, greater empathy. Maybe, someday, I'll even become a bug person.

But the second that kid brings home a spider, it'll be Dad's turn to change and grow. I'll be out back with the baby birds.

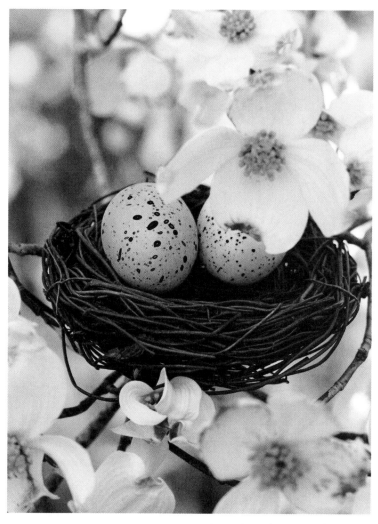

Image © Stephanie Frey/Shutterstock

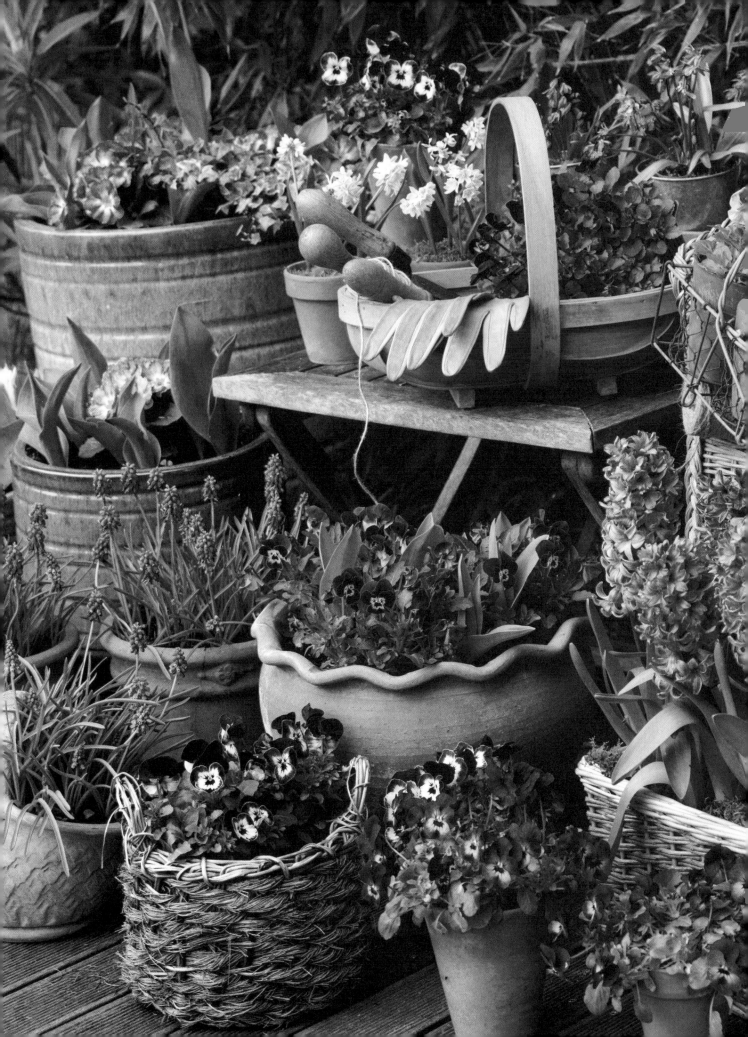

Spring
Mildred Musgrave Shartle

Spring has come with its purple and gold—
a royal time of the year!
The meadowlark flashes his clean yellow breast
as he gladly calls, "Spring is here!"

The purple-blue violets grow deep in the woods;
there are dainty yellow ones too;
and buttercups gleam through the
 fast-growing ferns,
as they glisten with morning dew.

Bright lemon lilies, slender and tall,
rise from the winter's cold;

yellow tulips with lavender markings
their sunny petals unfold.

Pansies of purple, trimmed with gold,
open their smiling faces;
sweet-scented hyacinths bloom around town
as they stand in the same old places.

The sun shines down with a golden ray;
the oriole brings good cheer,
for spring has come with its purple
 and gold—
a royal time of the year.

*And the spring arose on the garden fair, like the spirit of love felt everywhere;
and each flower and herb on Earth's dark breast rose from the dreams of its wintry rest.*
—PERCY BYSSHE SHELLEY

FROM
Lines Written in Early Spring
William Wordsworth

Through primrose tufts, in that green bower,
the periwinkle trailed its wreaths;
and 'tis my faith that every flower
enjoys the air it breathes.

The birds around me hopped and played:
their thoughts I cannot measure,
but the least motion which they made,
it seemed a thrill of pleasure.

The budding twigs spread out their fan
to catch the breezy air;
and I must think, do all I can,
that there was pleasure there.

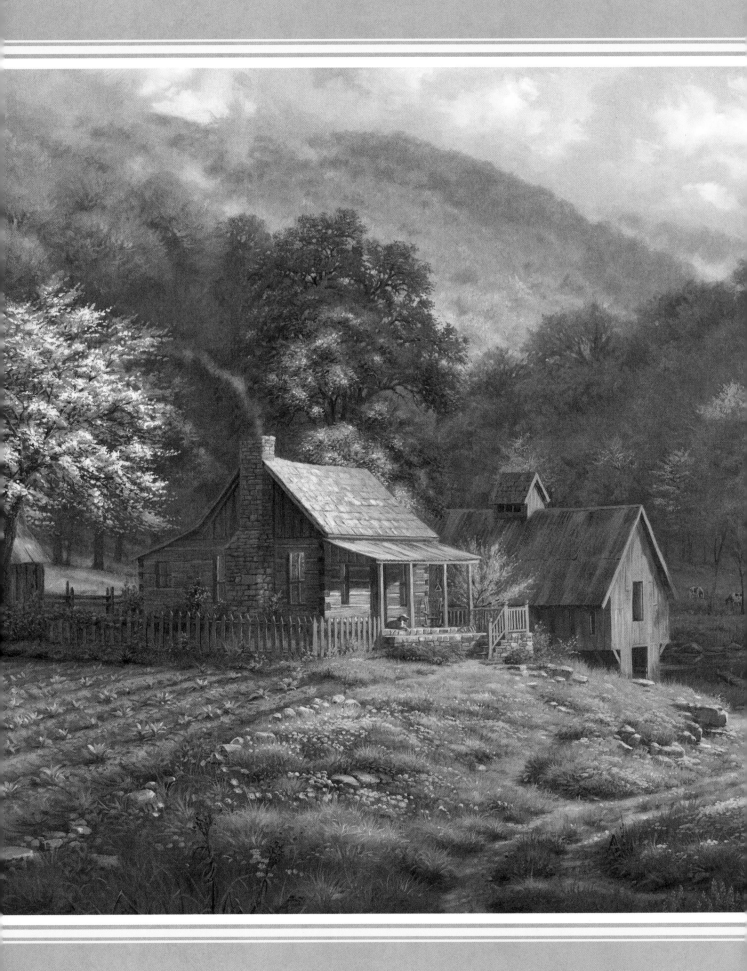

Hello, Springtime!
Lorna Volk

Goodbye, winter's ice and snow
and the freezing winds that blow;
hello, springtime's gentle rain
upon the hillside and the plain.
Welcome, rays of warming sun
as flowers open one by one.

Spring Quiet
Christina G. Rossetti

Gone were but the winter,
come were but the spring,
I would go to a covert
where the birds sing;

where in the whitethorn
singeth a thrush,
and a robin sings
in the holly bush.

Full of fresh scents
are the budding boughs
arching high over
a cool green house:

full of sweet scents
and whispering air,
which sayeth softly,
"We spread no snare;

"here dwell in safety,
here dwell alone,
with a clear stream
and a mossy stone.

"Here the sun shineth
most shadily;
here is heard an echo
of the far sea,
though far off it be."

COUNTRY BLESSINGS *by Mark Keathley. Image © Mark Keathley*

Pussy Willows

Joan Donaldson

Like sighting the first robin hopping across a lawn or hearing a flock of geese flying north, pussy willows are also one of the first signs of spring. I remember the small bushes that grew near my house as a child. Their gray catkins glowed on slim branches that waved in the March winds and proclaimed the dwindling power of winter. The willows grew in low spots where puddles lasted for several days. In mid-February, my mother would cut a few branches of pussy willows and forsythia and place them in a vase. The warmth of the room forced the buds to open, and soon the gray little cats appeared beside the forsythia's yellow bells.

When a late storm tossed snowflakes about the Michigan landscape, the soft and fluffy egg-shaped blossoms became my indoor toys. I cut thread and glued tails on some and pretended they were mice. Or I pasted on pointed ears and tails from yarn and transformed them into their namesakes. My dolls had kittens to play with until the silver catkins fell apart. Sometimes while reading a book, I rubbed them against my cheek or rolled them between my fingers, enjoying their soft fur. I found them comforting, like cuddling a stuffed animal. After marrying, I followed my mother's tradition of forcing a bouquet of pussy willows to bloom. When my family ate dinner, my sons would comment on how much the blossoms had emerged. As the catkins matured and dropped to the table, instead of appreciating their softness, my boys turned them into projectiles and threw them at each other.

During early March, I watch our two pussy willow trees, noting how each day the buds peek out a little farther. When the flowers emerge completely, the tree shimmers in the sunlight as if someone had strung silver lights across the branches. The catkins are not one solid flower but are composed of dozens of individual segments, such as how Saint Paul described the church, "The body is a unit, though it is made up of many parts" (1 Corinthians 12:12, BSB). Depending upon the spring temperatures, the pussy willows can bloom for several weeks. Then one day, a fine yellow pollen clings to thread-like whiskers, each one attached to a tiny section. Eager bees crawl over the powder seeking nectar during a time when few plants are flowering. After the bees collect the nectar, the pussy willow flower's segments crumble apart. The wind scatters some of the seeds, while mice and birds carry many of them away and plant them.

At first I do not notice the new pussy willows growing near a pond or along a ditch bank because numerous blackberry brambles and wild rose canes hide the slender stalks. But when the pliant branches extend about three feet, I spy a few silver pussy willows bobbing in the gusts of wind. I give thanks for the tiny creatures who sowed these humble bushes that provide a tactile reminder how the days are growing longer and warmer. I cut a few branches to bring inside the house and to show my grandchildren. May they, too, discover the joy of playing with the gray catkins as a way of celebrating spring.

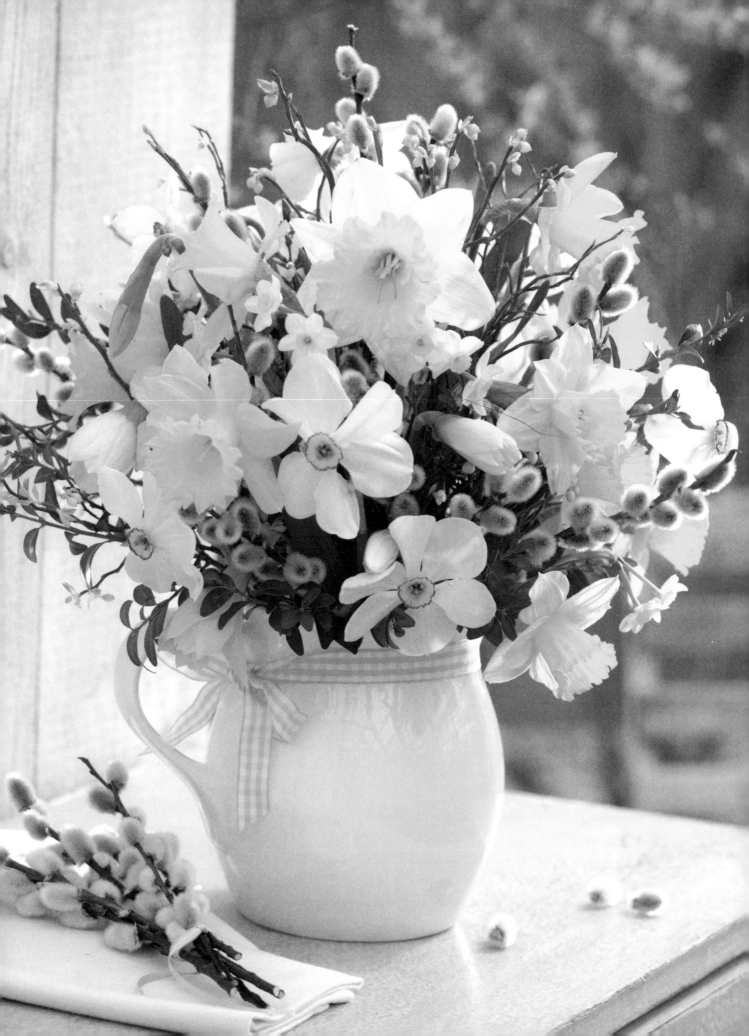

Sister Dresses

Faith Andrews Bedford

*A*s my sister's car disappears over the top of the hill, her faint *toot* in farewell tells me she has turned onto the main road. The dust settles on our lane as I look to the pile of boxes she just left behind. I sit down on the top step of the porch and open a box marked "Albums." Here are photographs of my father, resplendent in his Navy uniform, and one of my mother leaning against their first car. Then, there on the last page, is the picture of us in our sister dresses.

I can almost feel the starched ruffles and hear the rustle of the crinolines that were needed to keep the skirts nice and full. I remember Mother's delight when she found these dresses at the children's shop in the village. There was one in my size and one for Ellen but no size four for Beth. We were so excited when Mrs. Page, the shopkeeper, told us she felt sure she could order one for Beth that would come in time for Easter.

When the big box arrived in early April, we gathered around Mother as she lifted the dresses out one by one. The pink tissue paper rustled as she held each one up. They were made of clouds of dotted Swiss organdy with blue-flocked dots. The skirt and collar were trimmed with tiny blue bows. "To match your eyes," Mother had said. We were allowed to try them on just once so that we could have a "fashion show" for Father that evening. As we twirled into the dining room in our new finery, he burst into applause. Ellen and I daintily grasped the ruffled skirts and executed our best curtsies; Beth scrunched her dress up in her chubby little hands and made a close approximation of one, almost toppling over in the process. Then we had to carefully hang our finery up until Easter Sunday. As I look at the photograph, I can recall the warmth of the pale spring sunshine on our faces that day. We undoubtedly resisted putting on coats to go to church. They surely would have crushed those beautiful dresses and besides, how then could anyone have seen how wonderfully we matched?

In time, I handed my dress down to Ellen and she handed hers down to Beth. Finally, only Beth had one of those beautiful dresses, its bow a bit bedraggled after countless wearings by three little girls. But those dotted Swiss dresses were only the beginning of a long parade of matching sister outfits. Mother obviously was so pleased with the effect that she began an Easter tradition. I remember the year of the blue calicoes and the year we all had matching yellow jumpers. Even Father got into the spirit of things when he came back from a business trip to Arizona with dresses for each of his girls—even

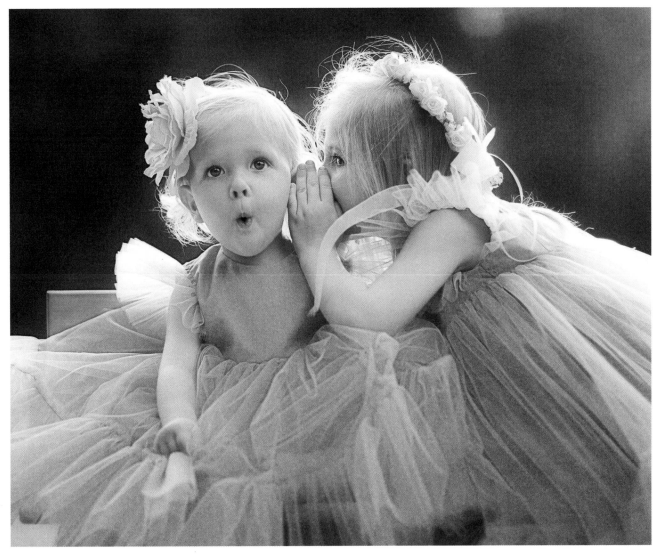

Mother. Those wonderful white dresses with rows and rows of bright ribbons edging the wide collars and hems had skirts that were cut in a complete circle. We spun madly about the living room, our beribboned skirts fluttering like crazed butterflies. At last we crashed, giggling, into a heap. Dad, quite pleased with our reaction to his gift, sat in his armchair and grinned his "that's-my-girls" smile.

Gradually, as we grew older, I think Mother saw how very different we all were becoming and just stopped buying us matching dresses. Yet she didn't realize the impact of this meaningful tradition. Years later when I had a family of my own, I was expecting my third child, and I made myself a maternity dress out of some bright pink cotton. Eleanor, my elder daughter, loved the fabric, so I made a jumper for her out of the scraps. That third baby turned out to be a girl—a little sister for Eleanor. So in a way Mother's special tradition of "sister dresses" continued with my girls, even before birth.

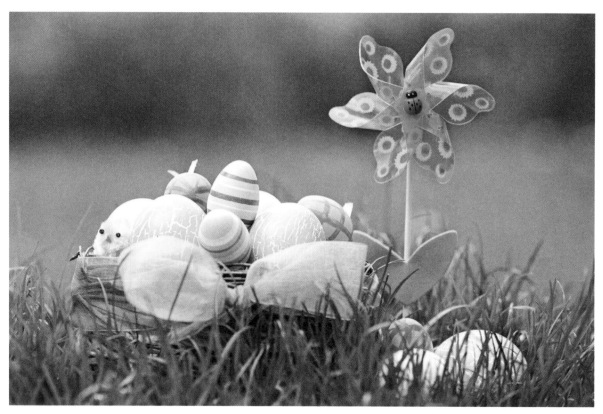

Image © Stockfotografie.net/Adobe Stock

A Family Egg Hunt

Marilyn Jansen

By the time we had three children, we were outnumbered and out-energized. We had to rely on the older kids to help take care of the youngest. Jasmine, the oldest, was good at mothering her little brothers. But Joel, the middle child, was more stand-offish. He watched his little brother from a distance, adjusting his play to make sure baby brother Jackie stayed safe, but never directly engaging him. It was fascinating to watch.

When the kids were eight, five, and one, we had a modified Easter egg hunt. For Jackie,

we filled plastic eggs with age-appropriate toys, candy, and the family favorite—candy-studded marshmallow treats. Jasmine and Joel got decorated real eggs and plastic eggs filled with money or treats. We hid them in the backyard, leaving Jackie's larger eggs in full view for easy retrieval.

Once the kids started the hunt, Jasmine took Jackie to his first egg and then abandoned him to run looking for the big kids' eggs. Joel was already putting eggs in his adorable wicker basket. Jackie sat down

and played with his egg but couldn't get it opened. He lost interest, spied another large egg, and toddled off to capture it. He sat down and again tried to open his prize egg, but his fat little fingers weren't quite up to the task. As Jasmine squealed with delight, I stepped in to help Jackie open an egg. Once he realized the colorful egg had a marshmallow treat inside, he was excited to get more. He raced toward the next egg as fast as his chubby baby legs would allow. That egg opened easily. And so did the next.

I took a minute to observe the other kids and realized that Joel was going before Jackie and cracking open his eggs. He would leave them half opened so that when Jackie found them he could get his little fingers inside and fish out the treats. I was amazed. Joel was looking out for his little brother from a distance, even though it meant Jasmine was getting the lion's share of eggs. My heart melted.

As my boys have grown, they have become close friends. They look out for each other. They still hunt together, but their quarry is more often a great coffee shop or classic vinyl album. One thing they both still look forward to, however, is Easter eggs stuffed with marshmallow treats.

Trail-Mix Marshmallow Treats

6 *tablespoons butter, plus more for shaping*
6½ *cups mini marshmallows*
1 *7-ounce jar marshmallow creme*
1 *teaspoon vanilla extract*

8 *cups crisp rice cereal*
½ *cup pecans (or nut of your choice)*
½ *cup dried cranberries, optional*
½ *cup candy-coated chocolate pieces*

Wash and dry 18 to 20 3-inch plastic eggs. Lightly spray inside of each egg with non-stick cooking spray. In a large saucepan or Dutch oven, melt butter. Add mini marshmallows and continue stirring until melted. Stir in marshmallow creme and vanilla. Remove from heat; gently stir in cereal, nuts, and cranberries, if desired. Allow mixture to cool 2 to 3 minutes; fold in chocolate pieces. Working quickly with buttered waxed paper, press marshmallow mixture firmly into each egg half, then press halves together, enclosing mixture inside egg. Let cool at least 1 hour.

Treats can remain inside eggs or be removed from plastic. May be stored up to 2 days at room temperature in airtight container. Makes approximately 18 to 20 egg-shaped treats.

Easter
Garnett Ann Schultz

Easter hath her blessing
and Easter hath her charms;
Easter is a precious miss
soft in springtime's arms.

The time of resurrection,
of life and hope anew—
Easter is a treasured time
that brings a peace to you.

Easter hath real meaning:
God is close at hand,
offering forgiveness;
He can understand.

Let us sing His praises
on this holy day.
Easter is forever . . .
keep it just that way.

Easter with the Little Ones
Mary A. Lathbury

Into mine own this sacred hour,
sweet eyes are lifted up—
each little face a lily flower,
each heart a lily cup.

My Easter lilies! Risen Lord,
I offer them to Thee—
each heart a chalice for
 Thy life,
Thy love, Thy purity.

Like Mary by the garden tomb,
with lilies round her feet,
I kneel among my little ones,
who lift their faces sweet,

and say, "Dear Master, take
 Thine own,
we give ourselves to Thee—
I and the children, Lord of life,
whom Thou hast lent to me."

A LESSON IN GRACE *by Kathy Fincher. Image © Kathy Fincher*

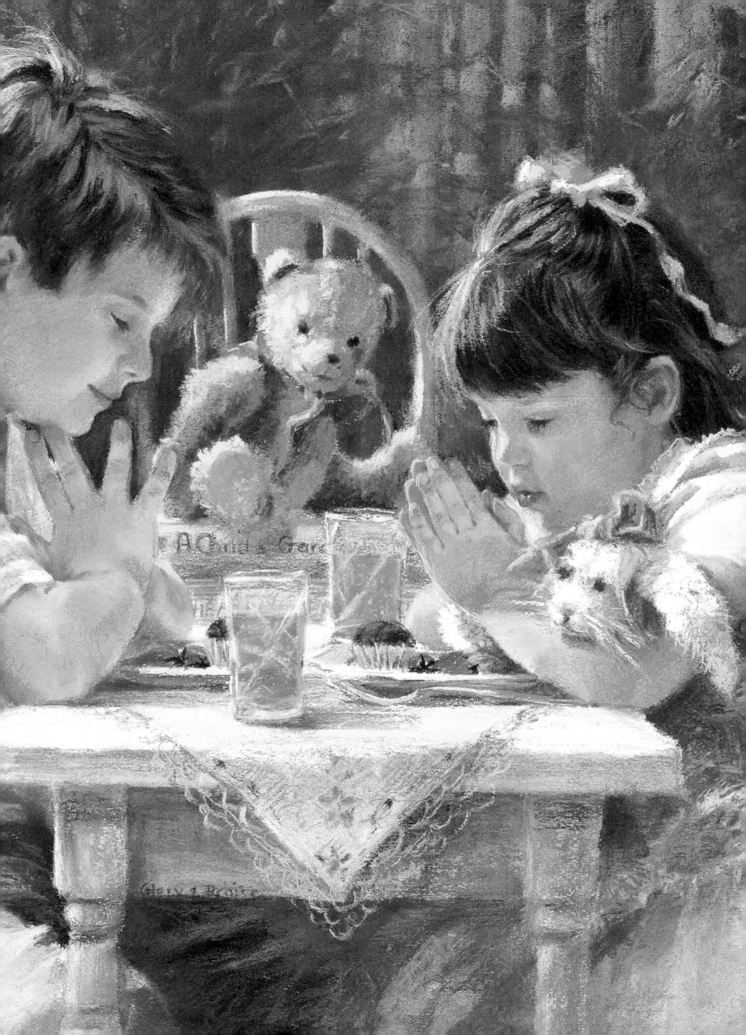

Through My Window

An Empty Easter

Pamela Kennedy

This past spring, things were different. Due to quarantine protocols, we had to cancel travel plans to see far-flung family. Social distancing was the norm. When Easter came around, the church was locked, and we were not able to gather in a sanctuary filled with the scent of lilies and the sounds of the choir. Instead, my husband and I gathered in our kitchen with steaming cups of coffee and toasted sweetbread dripping with melted butter. We watched Easter services online, singing hymns together, alone. The sermon was inspiring and the prayers heartfelt, but Easter felt as empty as the tomb in Jerusalem.

In the afternoon we drove to our son's home, an hour away. We came laden with Easter gifts—not in beribboned baskets filled with purchased toys and sweets, but in a bucket and a box. My husband had spent the previous weeks building a beanbag toss board for the grandchildren. He had lovingly sanded and stained it, joining front to back with hinges, applying numbers to each of the circular holes so our seven-year-old mathematician could practice his addition skills. I sewed together felt squares, then filled them with popcorn kernels because anxious shoppers had emptied the market of dried beans and other essential grocery items. We dug a bucket of clams

for our son and purchased a couple of avocados and a handful of carnations at the grocery store for our daughter-in-law. At the last minute, we grabbed an extra package of toilet paper from our pantry to tuck in.

When we arrived, we parked on the street in front of their home and the little family rushed down the driveway to greet us. Then they stopped, a good ten feet away, waving their arms in "air hugs" shouting "Happy Easter, Grammy and Papa!" We blew them kisses and unpacked our car, setting the wooden board and beanbags on the grass, placing the box with our other gifts at the end of the driveway, then backing away. The breeze fluttered brand-new leaves on the maple tree, and daffodils nodded in the garden. My arms ached for a hug that wasn't just filled with air.

"Hey, Grammy! Watch! I can ride a two-wheeler now!" Evelyn, the four-and-a-half-year-old, whipped on her turquoise helmet and ran to get her bike. She walked it to the street, then climbed aboard. Wobbling and swerving, she took off, peddling madly. We laughed at her eager efforts to ride in a straight line.

"Look at me, Papa!" her brother shouted. He leapt onto his shiny red bicycle and quickly

caught up with his sister, made a fast turn, and sped back, taking a short jump over a pile of dirt.

The children laughed and squealed in the spring sunshine while we adults caught up on family news in person—at a safe distance. We took pictures and videos on our phones. Then, saying our goodbyes, we waved and blew kisses once more.

How odd, I thought on the way home, to celebrate a holiday that reminds us that death is vanquished, while under a quarantine that remind us of our human frailty. But maybe this vulnerability is an aspect of Easter I do need to remember. Because when Jesus demonstrated the power of heaven, He triumphed by embracing His humanity. And despite this seeming vulnerability, a Roman governor could not destroy Him. A cross could not defeat Him. A stony grave could not contain Him. And millennia of history could not erase Him.

I scrolled through the pictures on my phone, smiling at the eager faces of my grandchildren and their parents. Here were Easter memories certainly different from years past, but perhaps more precious for just that reason. Maybe this Easter wasn't as empty as I had first imagined.

Instead it had taught us, more than ever before, that life goes on. Leaves still burst forth and flowers still bloom. The children continue to learn and grow. We move forward—slowing down and even, at times, wobbling like a child learning to ride, but always forward. Easter's relentless, amazing power still fills the world around us. And it's unstoppable.

The Immortal Drama

Grace Noll Crowell

Here is the greatest drama of all ages:
a drama closing with a burst of light,
with dawn upon the hills, and the earth quaking,
and an angel, glittering white.

Here is an act stupendous, fraught with meaning:
the risen Christ stands straight and clean and still
as a lighted tower beside a darkened ocean,
as a tree upon a hill.

A haven for the storm-tossed and the helpless,
a shelter for the pilgrims of all lands,
the central figure in an immortal drama,
the risen Christ stands.

The curtain falls upon His earthly lifetime;
we wept for Him, but He has dried our tears;
here is eternal joy, eternal rapture
for the eternal years.

We watch with wonder as a cloud receives Him;
the drama ends, and yet the sons of men
turn back to daily tasks, assured and certain
that He will come again.

O risen Christ! O Easter flower!
How dear Thy grace has grown!
From east to west, with loving power,
make all the world Thine own.

—Phillips Brooks

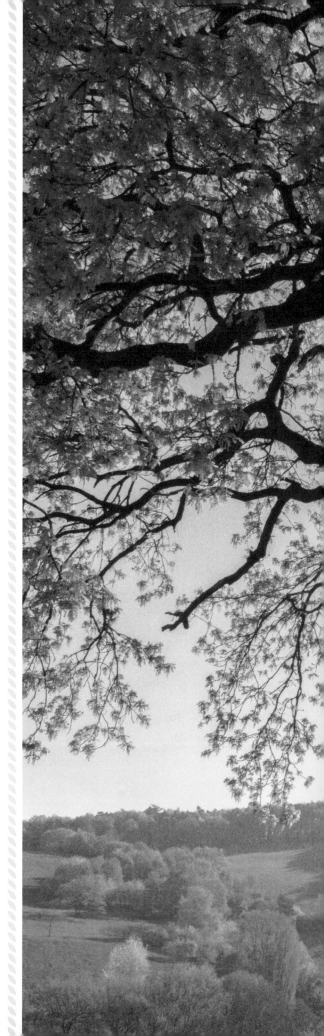

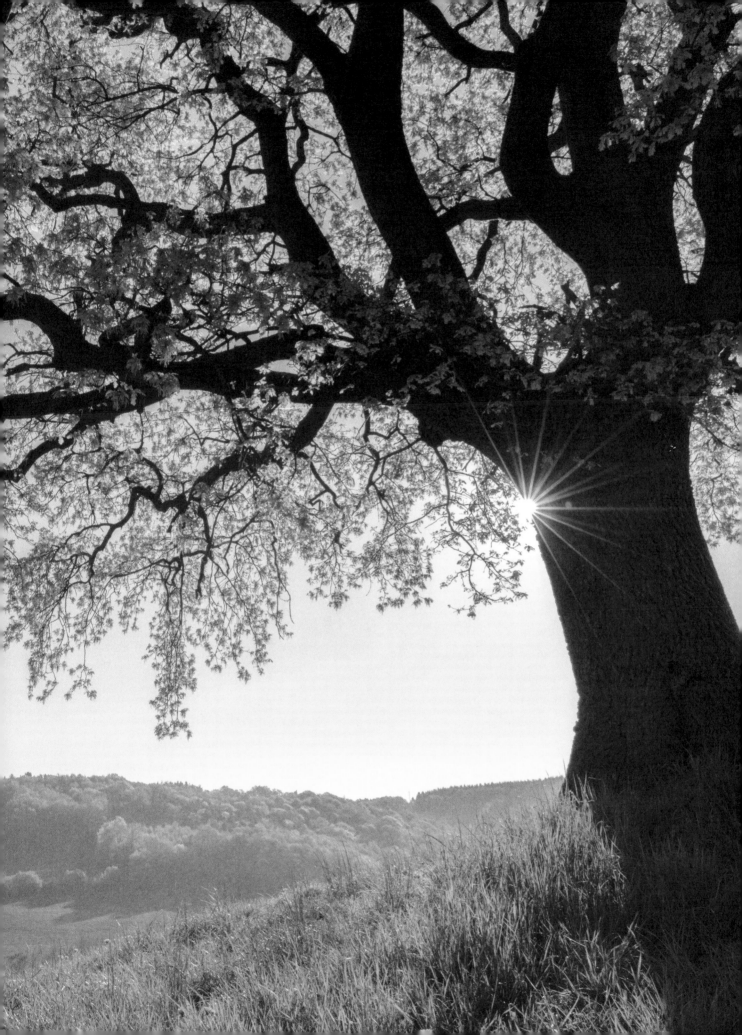

A Widow's Offering

BASED UPON SELECTIONS FROM MARK 11 AND 12

Pamela Kennedy

Hurry! He's coming!"

Shouting children dashed past Amira, knocking over the widow's begging bowl, spilling the three small coins she had collected. Quickly she gathered up the dusty pieces of copper, then, clambering onto a low wall, Amira peered over the crowd. People pushed to get closer, calling out and waving palm branches. A young man sat upon a donkey as it clopped along the road. Cries filled the air: "Hosanna! Blessed is he who comes in the name of the Lord!" "Blessed is the coming kingdom of our father David!" "Hosanna!"

Curious, she followed, watching as the young man dismounted then walked around the temple courtyard. He said nothing, but only smiled at the children dancing before him. As the sun dipped behind the temple walls, he gathered his friends and left. Amira wrapped her cloak around herself and crept into an abandoned horse stall. Settling into a corner, she nibbled on the small loaf of bread she had purchased with one of her coins. Falling into a deep sleep, she dreamed of the past, of happy times when she had been a young wife, filled with hope.

In the morning, Amira set out again for the temple court. Passover was approaching, and perhaps there would be visitors who would take pity and toss her some change. She settled onto the ground near the moneychangers' tables. Suddenly, she heard shouts, then screams. Tables crashed, money scattered, lambs bleated, doves fluttered in the dusty air. Amira scrambled to her feet to avoid being trampled. There

stood the man from yesterday. He held a knotted cord in one hand and shouted at the cowering sellers. "Is it not written: 'My house will be called a house of prayer for all nations'? But you have made it a den of robbers!" He turned and strode from the temple courtyard, leaving an astonished crowd in his wake.

The moneychangers ran after their scattered wares, while the chief priests and religious lawyers gathered in small, angry groups. There were dangerous forces at work in Jerusalem, and somehow this man was involved. Amira retreated to her hiding place.

When she returned to the temple courts the next morning, it was as if nothing had happened. Then she saw a small group approaching. There he was again, the man who had ridden the donkey and overturned the tables. She crept closer and listened as the Sadducees questioned him about the resurrection of the dead and the fate of a widow married seven times. She wondered as the Teacher explained that God is not the God of the dead, but of the living. A lawyer asked him to name the greatest of all the commandments, and the man spoke with authority when he answered, "Love God first, then love your neighbor."

Amira pushed even closer to sit near the Teacher's feet. His words were like water quenching her parched soul. He talked about treating the poor with kindness, of helping widows and orphans. He scolded the religious leaders for their arrogance and for mistreating those on the margins. His words reminded Amira of

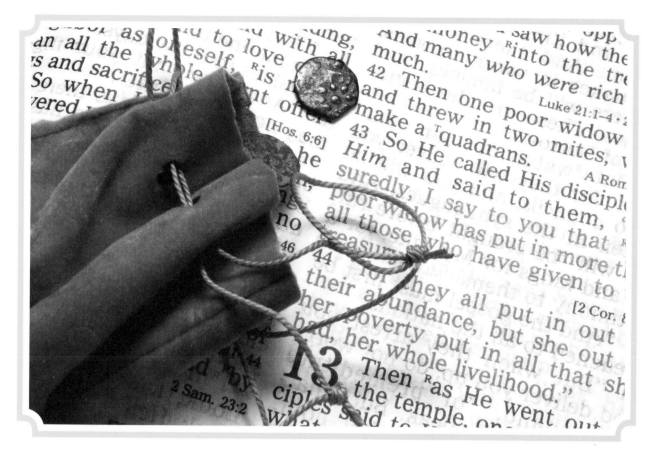

the Scripture stories she had heard as a child. Her favorite was about the prophet Elijah and a poor widow from Zarephath. The widow had just enough food and water for one more meal when Elijah had asked her to give it all to him. In faith, the woman gave everything she had to the prophet. And then a miracle happened. The widow's water and food were replenished daily and she never again went without.

Amira smiled remembering the story, then she glanced up. The Teacher was looking into her eyes with a tenderness she had never known. Her heart warmed. Suddenly she knew what she needed to do. Reaching into the small bag hanging at her belt, she felt the two copper coins, all she had left. Across the courtyard the large, fluted offering jar stood on a low platform. One by one, people deposited their offerings, the money clanging loudly as it tumbled in.

Amira stood in line, ignoring the glances of the well-dressed worshipers. She thought about that other widow from centuries ago who gave everything she had because she believed the prophet's words. She glanced again at the Teacher, reached out her hand, and dropped in her last two coins.

As she turned to go, Amira heard a man's voice call, "Woman, the master would like you to join us for our evening meal!"

Amira turned and looked once more into the eyes of the Teacher. He smiled. Her heart, so empty just moments ago, felt a strange fullness. In that small transaction of faith, of giving her poverty to Him, everything had changed. She felt welcomed, not rejected. Seen and valued for the first time in decades. Amira realized that this was the source of true abundance: trusting in the One from whom all blessings flowed.

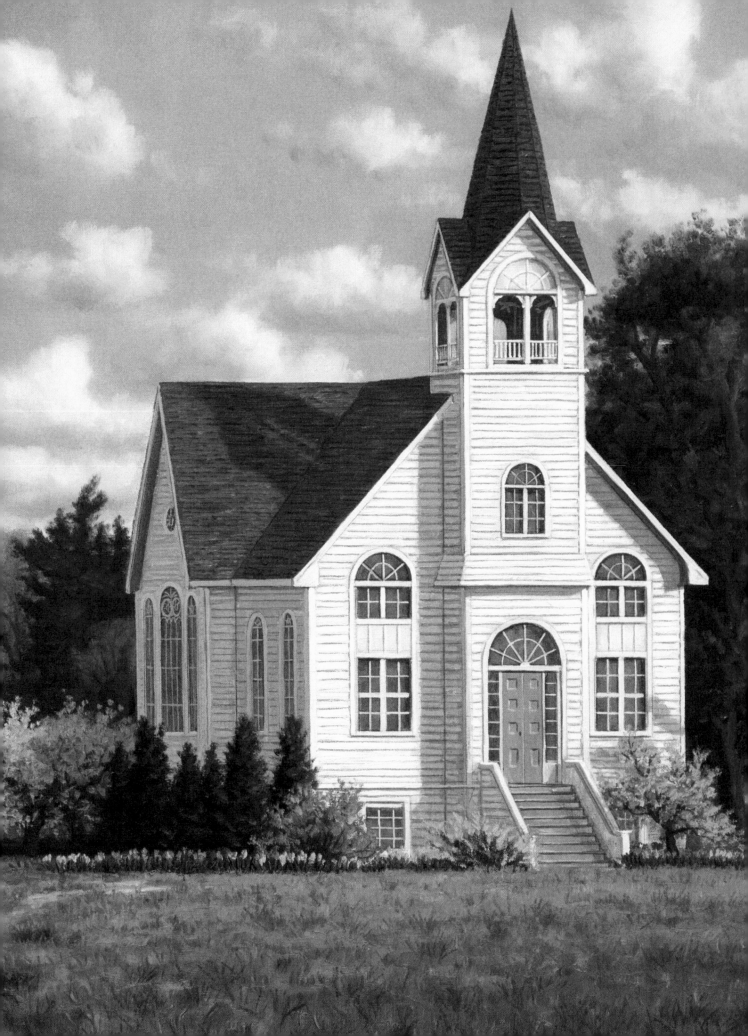

To Hail Him with Palm

Edgar A. Guest

A gentle spirit past them rode
of whom they'd merely heard . . .

He owned no land, and
 no abode,
and yet their hearts were stirred.

But this they clearly understood:
all pleas He tried to heed,

His heart was bent on doing good
wherever there was need.

And so with palm they
 strewed His way
and greeted Him with cheers;

they made of it a holy day
to last throughout the years.

So great His love, it still can be
for troubled hearts a balm.

This day we turn in memory
to hail Him still with palm.

Bells on Palm Sunday

M. Kathleen Haley

On this lovely Sabbath morning
while the church bells sweetly ring,
there's a message in their chiming:
they proclaim to us a King.

They are telling of the Savior
as He braved that
 throng-packed street,

of the palm bough gladly offered—
carpet for small donkey feet.

Now the church bells mount
 in volume
that the whole wide world may hear
of that wondrous coronation—
each hosanna—every cheer!

CONWAY CHURCH 2 *by Randy Van Beek.*
Image © Randy Van Beek/Art Licensing

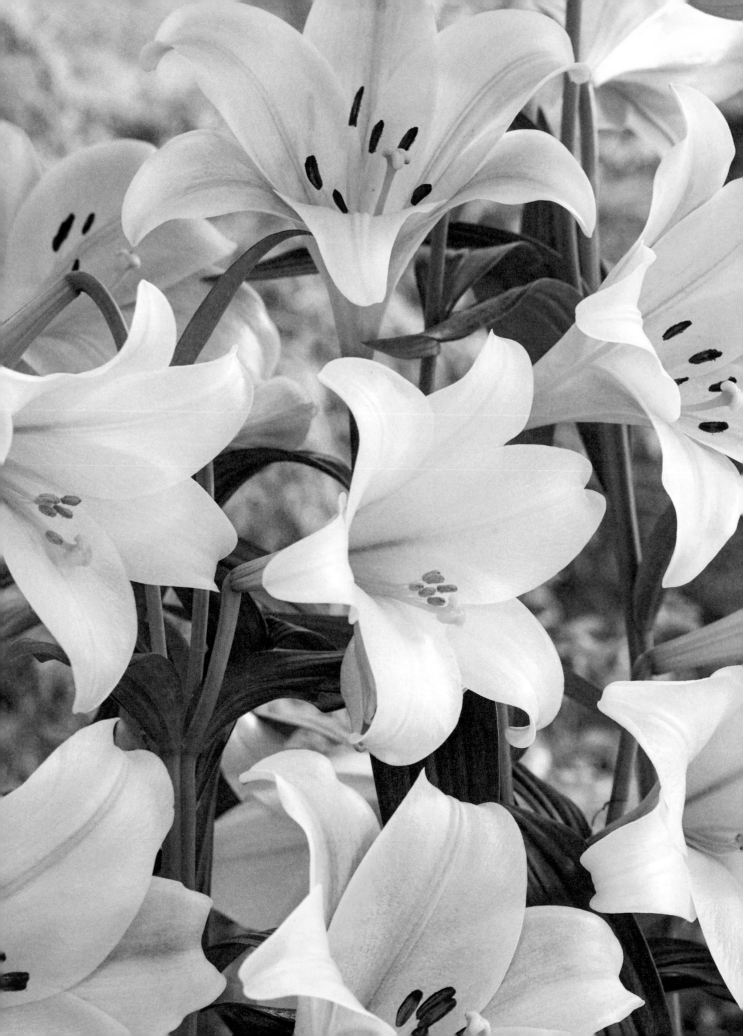

Lily Blossoms
Author Unknown

Lovely are the lily blossoms;
sweet, the music of the choir;
sacred are the Holy Scriptures
and the thoughts that they inspire.

Hopeful is the Easter message;
precious is the faith we share;
may these blessings make
 you happy
at this time of praise and prayer.

Heaven and earth,
and saints and friends and flowers
are keeping Easter Day!
—Author Unknown

Lily Light
Pamela Love

Lilies have a star-like shape.
They seem to light the way
for people walking into church
on happy Easter days.

Bright white flowers made by God
that almost seem to glow
remind us when we see them
how much to Christ we owe.

Image © Visions/GAP Photos

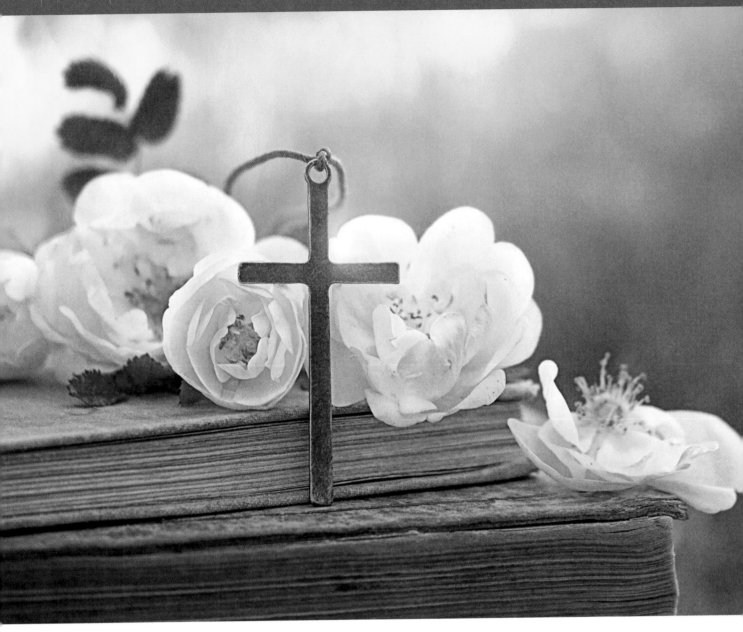

Crucify Him

FROM *THE LIFE OF OUR LORD*

Charles Dickens

That you may know what the people meant when they said, "Crucify Him!" I must tell you that in those times, which were very cruel times indeed (let us thank God and Jesus Christ that they are past!), it was the custom to kill people who were sentenced to death by nailing them alive on a great wooden cross, planted upright in the ground, and leaving them there, exposed to

the sun and wind, and day and night, until they died of pain and thirst. It was the custom, too, to make them walk to the place of execution, carrying the cross-piece of wood to which their hands were to be afterwards nailed—that their shame and suffering might be the greater.

Bearing His cross upon His shoulder, like the commonest and most wicked criminal, our blessed Savior, Jesus Christ, surrounded by the persecuting crowd, went out of Jerusalem to a place called in the Hebrew language, Golgotha—that is, the place of a skull. And being come to a hill called Mount Calvary, they hammered cruel nails through His hands and feet and nailed Him on the cross, between two other crosses, on each of which a common thief was nailed in agony. Over His head, they fastened the writing "Jesus of Nazareth, the King of the Jews" in three languages: in Hebrew, in Greek, and in Latin.

Meantime, a guard of four soldiers divided His clothes into four parcels for themselves, and cast lots for His coat, and sat there gambling and talking while He suffered. They offered him vinegar to drink, mixed with gall; and wine, mixed with myrrh, but He took none. And the wicked people who passed that way mocked Him and said, "If Thou be the Son of God, come down from the cross." The chief priests also mocked Him and said, "He came to save sinners. Let

him save Himself!" One of the thieves, too, railed at Him in His torture and said, "If Thou be Christ, save Thyself, and us." But the other thief, who was penitent, said, "Lord! Remember me when Thou comest into Thy Kingdom!" And Jesus answered, "Today, thou shalt be with me in Paradise."

None were there to take pity on Him but one disciple and four women. God blessed those women for their true and tender hearts! They were the mother of Jesus; his mother's sister, Mary; the wife of Cleophas; and Mary Magdalene, who had twice dried his feet upon her hair. The disciple was he whom Jesus loved—John, who had leaned upon His breast and asked Him which was the Betrayer. When Jesus saw them standing at the foot of the cross, He said to His mother that John would be her son, to comfort her when He was dead; and from that hour John was as a son to her, and loved her.

At about the sixth hour, a deep and terrible darkness came over all the land, and lasted until the ninth hour, when Jesus cried out with a loud voice, "My God, My God, why has Thou forsaken me!" The soldiers, hearing Him, dipped a sponge in some vinegar that was standing there and, fastening it to a long reed, put it up to His mouth. When He had received it, He said, "It is finished!" And crying, "Father! Into Thy hands I commend my spirit!" He died.

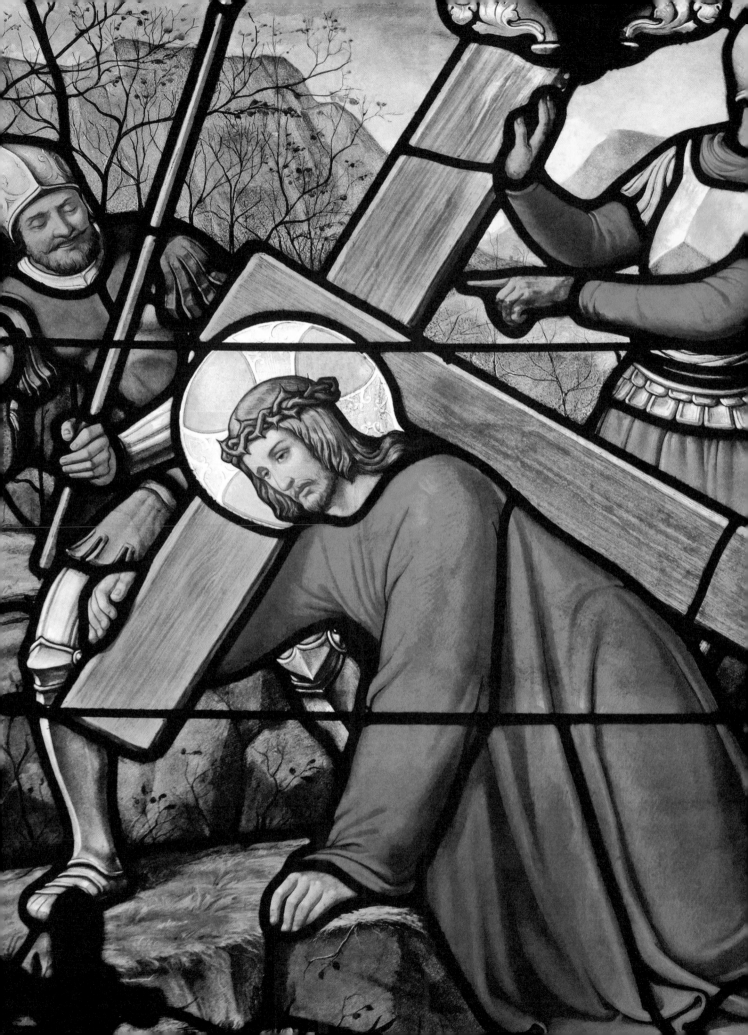

A Man with a Burden
Minnie Klemme

He was a Man with a burden—
it was written in the stars.
His birth was of wonder;
His death, one of scars.

And His life, that tells the story—
how He bade the waves to cease,
how He taught men to be brothers,
how He brought them love and peace,
how He bore upon His shoulders
all the evil men have wrought,
how He suffered their redemption
with His blood so dearly bought—
by His life, the good example,
men can bear their pain and loss.
He was a Man with a burden,
and He bore it to the cross.

HE HIMSELF BORE OUR SINS IN HIS BODY ON
THE CROSS, SO THAT WE MIGHT DIE TO SINS AND
LIVE FOR RIGHTEOUSNESS; BY HIS WOUNDS YOU
HAVE BEEN HEALED. —1 PETER 2:24 (NIV)

The Hands of Christ
John Richard Moreland

The hands of Christ
seem very frail,
for they were broken
by a nail.

But only they
reach heaven at last
whom these frail, broken
hands hold fast.

JESUS FALLS THE FIRST TIME, *Saint Eugene–Saint Cecilia Church, Paris, France.*
Image © by Zatletic/Adobe Stock

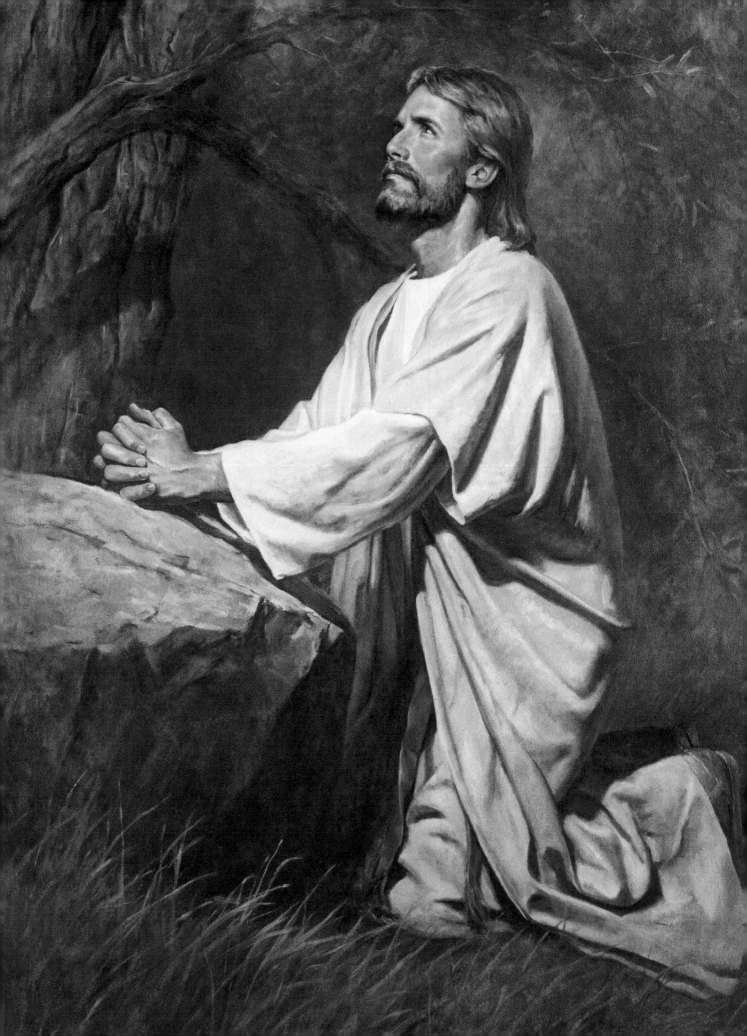

GETHSEMANE AND THE BETRAYAL
Mark 14:32–45

And they came to a place which was named Gethsemane: and he saith to his disciples, sit ye here, while I shall pray. And he taketh with Him Peter and James and John, and began to be sore amazed, and to be very heavy; and saith unto them, My soul is exceeding sorrowful unto death: tarry ye here, and watch.

And he went forward a little, and fell on the ground, and prayed that, if it were possible, the hour might pass from him. And he said, Abba, Father, all things are possible unto thee; take away this cup from me: nevertheless not what I will, but what thou wilt.

And he cometh, and findeth them sleeping, and saith unto Peter, Simon, sleepest thou? Couldest not thou watch one hour? Watch ye and pray, lest ye enter into temptation. The spirit truly is ready, but the flesh is weak.

And again he went away, and prayed, and spake the same words. And when he returned, he found them asleep again, (for their eyes were heavy,) neither wist they what to answer him.

And he cometh the third time, and saith unto them, sleep on now, and take your rest: it is enough, the hour is come; behold, the Son of man is betrayed into the hands of sinners. Rise up, let us go; lo, he that betrayeth me is at hand.

And immediately, while he yet spake, cometh Judas, one of the twelve, and with him a great multitude with swords and staves, from the chief priests and the scribes and the elders. And he that betrayed him had given them a token, saying, whomsoever I shall kiss, that same is he; take him, and lead him away safely. And as soon as he was come, he goeth straightway to him, and saith, Master, master; and kissed him.

THE CRUCIFIXION AND RESURRECTION
Mark 15:33–37; Mark 16:1–6

And when the sixth hour was come, there was darkness over the whole land until the ninth hour. And at the ninth hour Jesus cried with a loud voice, saying, Eloi, Eloi, lama sabachthani? which is, being interpreted, My God, my God, why hast thou forsaken me?

And some of them that stood by, when they heard it, said, Behold, he calleth Elias. And one ran and filled a spunge full of vinegar, and put it on a reed, and gave him to drink, saying, let alone; let us see whether Elias will come to take him down.

And Jesus cried with a loud voice and gave up the ghost.

And when the sabbath was past, Mary Magdalene, and Mary the mother of James, and Salome, had bought sweet spices, that they might come and anoint Him. And very early in the morning the first day of the week, they came unto the sepulchre at the rising of the sun. And they said among themselves, who shall roll us away the stone from the door of the sepulchre? And when they looked, they saw that the stone was rolled away: for it was very great.

And entering into the sepulchre, they saw a young man sitting on the right side, clothed in a long white garment; and they were affrighted. And he saith unto them, be not affrighted: ye seek Jesus of Nazareth, which was crucified: he is risen; he is not here: behold the place where they laid him.

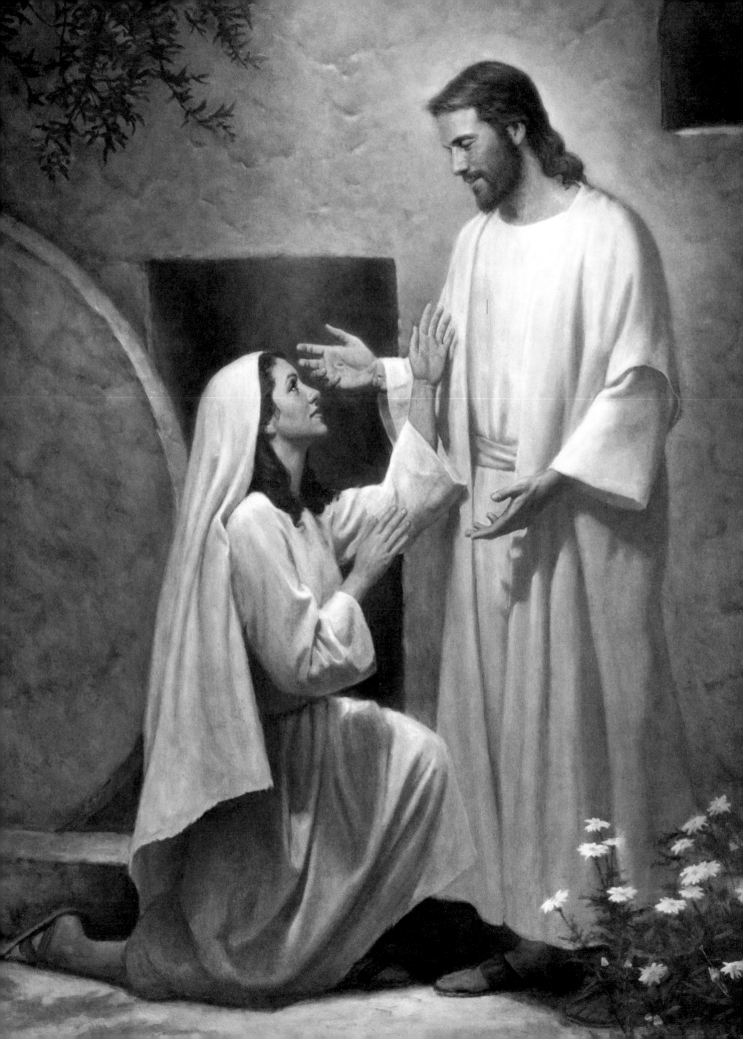

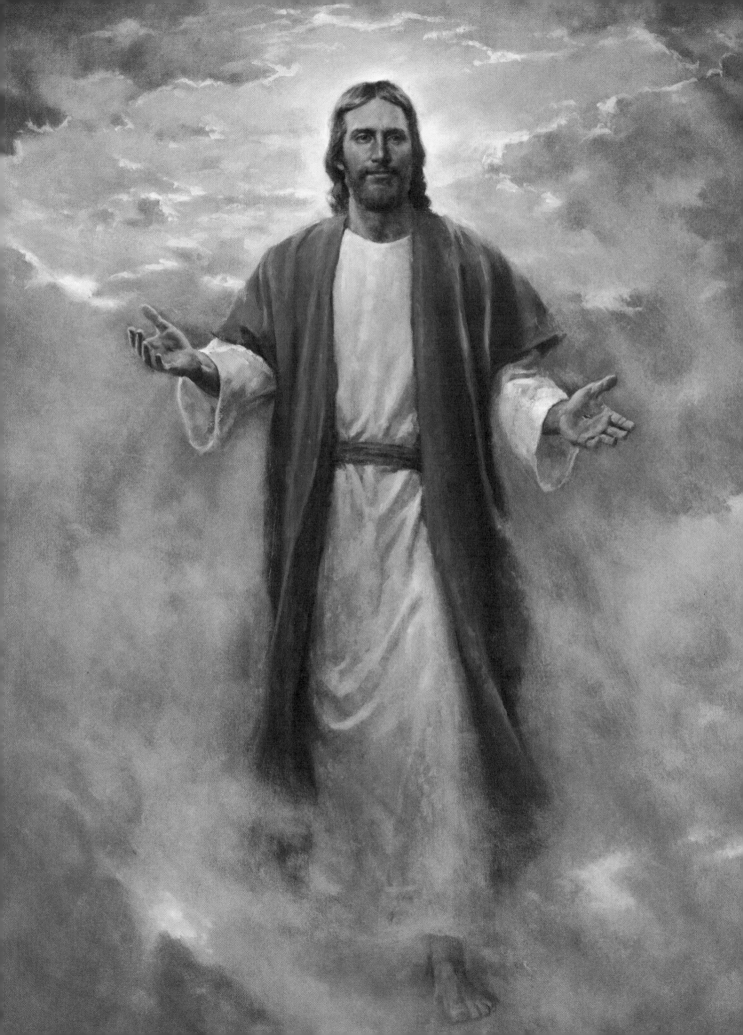

THE ASCENSION
John 14:1–6; Acts 1:6–11

Let not your heart be troubled: ye believe in God, believe also in me. In my Father's house are many mansions: if it were not so, I would have told you. I go to prepare a place for you. And if I go and prepare a place for you, I will come again, and receive you unto myself; that where I am, there ye may be also. And whither I go ye know, and the way ye know.

Thomas saith unto him, Lord, we know not whither thou goest; and how can we know the way?

Jesus saith unto him, I am the way, the truth, and the life: no man cometh unto the Father, but by me.

When they therefore were come together, they asked of him, saying, Lord, wilt thou at this time restore again the kingdom to Israel?

And he said unto them, it is not for you to know the times or the seasons, which the Father hath put in his own power. But ye shall receive power, after that the Holy Ghost is come upon you: and ye shall be witnesses unto me both in Jerusalem, and in all Judaea, and in Samaria, and unto the uttermost part of the earth.

And when he had spoken these things, while they beheld, he was taken up; and a cloud received him out of their sight. And while they looked steadfastly toward heaven as he went up, behold, two men stood by them in white apparel; which also said, Ye men of Galilee, why stand ye gazing up into heaven? this same Jesus, which is taken up from you into heaven, shall so come in like manner as ye have seen him go into heaven.

Low in the Grave He Lay
Robert Lowry

Low in the grave He lay, Jesus my Savior,
waiting the coming day, Jesus my Lord!

Vainly they watch His bed, Jesus my Savior;
vainly they seal the dead, Jesus my Lord!

Death cannot keep its prey, Jesus my Savior;
He tore the bars away, Jesus my Lord!

Up from the grave He arose,
with a mighty triumph o'er His foes;
He arose a victor from the dark domain,
and He lives forever, with His saints to reign.
He arose! He arose! Hallelujah! Christ arose!

Somewhere Angels Are Singing
Clay Harrison

Somewhere angels are singing
 their joyous songs of praise,
for it's Easter Day once more—
 the holiest of days!
Christ's empty tomb reminds us
 of His love and sacrifice.
Our sin debt is paid in full—
 His blood has paid the price!

Somewhere choirs are singing
 joyful praises to His name
for the Prince of Peace has risen
 and we thank God He came!
Our sins have been forgiven,
 nailed forever to His cross.
Without Him, we'd have no hope
 and great would be our loss!

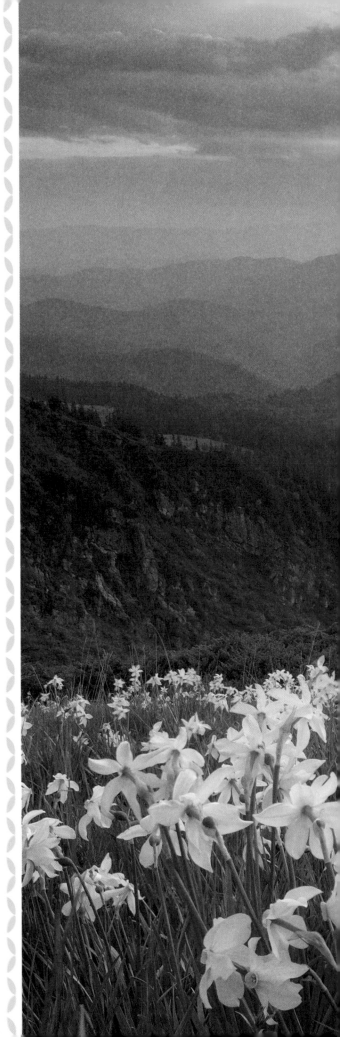

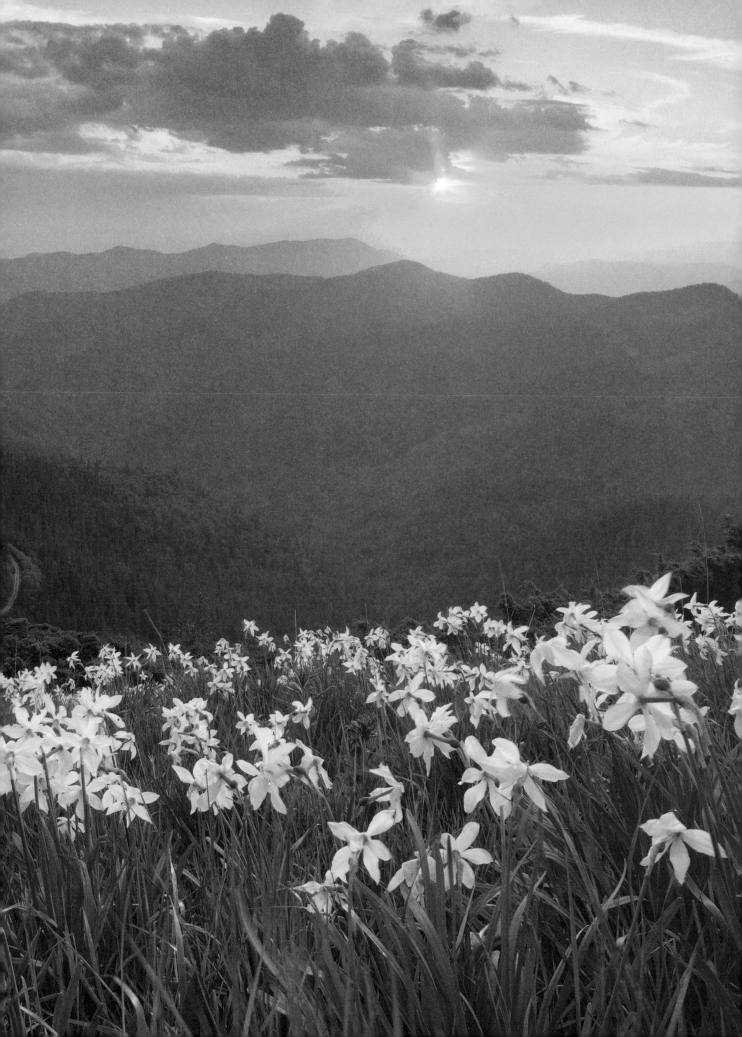

Family Recipes

Roasted Asparagus

2 bunches asparagus
2 tablespoons olive oil
½ teaspoon salt

Black pepper
Grated or shaved Parmesan
cheese, optional

Preheat oven to 450°F. Trim the woody ends from asparagus (usually about 1½ inches). Lightly peel stalks, if desired. Spread spears in a single layer on a baking sheet, drizzle with olive oil, sprinkle with salt and pepper to taste, and roll to coat thoroughly. Roast until lightly browned and tender, about 8 to 10 minutes, giving the pan a good shake about halfway through to turn the asparagus. Arrange the roasted asparagus on a serving platter and top with Parmesan, if desired. Serve warm or at room temperature. Makes 4 to 6 servings.

Red-and-Blue Tart

1 baked 8- or 9-inch tart shell
6 ounces cream cheese, softened
2 tablespoons granulated sugar
2 tablespoons milk

1 teaspoon lemon zest
½ teaspoon vanilla extract
1 cup fresh blueberries
1 cup sliced ripe strawberries

In a medium bowl, combine cream cheese, sugar, milk, lemon zest, and vanilla; beat until creamy and smooth. Spread cream cheese filling in tart shell; arrange blueberries and strawberries on top. Chill until set. Serve at room temperature. Makes 6 to 8 servings.

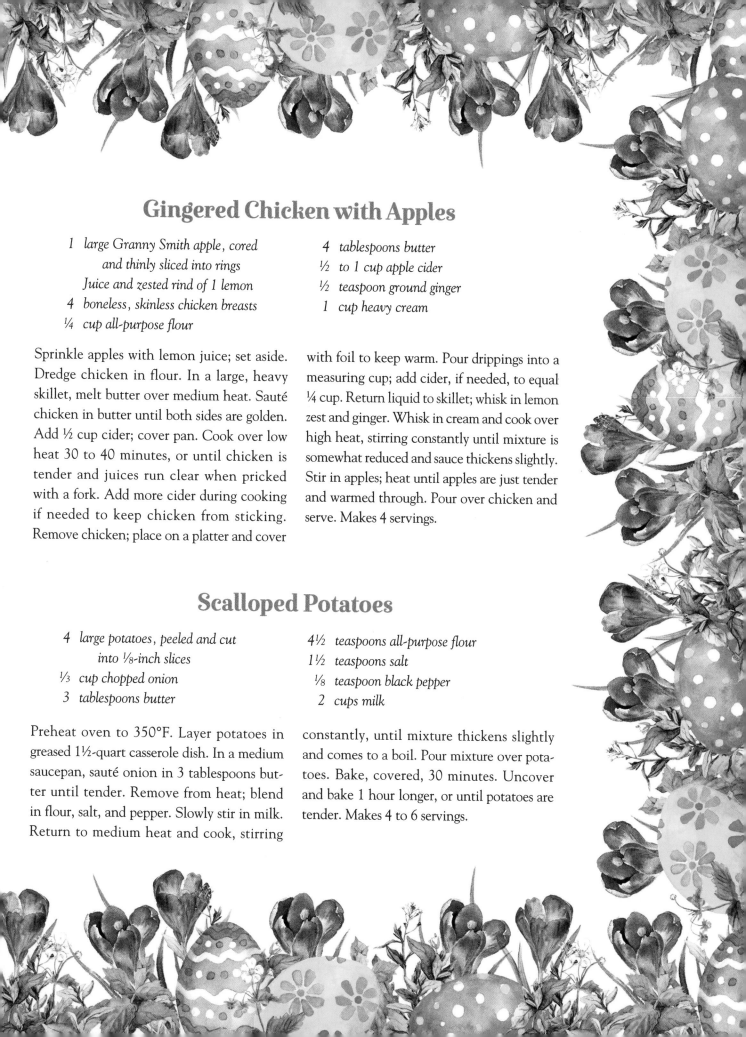

Gingered Chicken with Apples

1 large Granny Smith apple, cored
 and thinly sliced into rings
 Juice and zested rind of 1 lemon
4 boneless, skinless chicken breasts
¼ cup all-purpose flour

4 tablespoons butter
½ to 1 cup apple cider
½ teaspoon ground ginger
1 cup heavy cream

Sprinkle apples with lemon juice; set aside. Dredge chicken in flour. In a large, heavy skillet, melt butter over medium heat. Sauté chicken in butter until both sides are golden. Add ½ cup cider; cover pan. Cook over low heat 30 to 40 minutes, or until chicken is tender and juices run clear when pricked with a fork. Add more cider during cooking if needed to keep chicken from sticking. Remove chicken; place on a platter and cover with foil to keep warm. Pour drippings into a measuring cup; add cider, if needed, to equal ¼ cup. Return liquid to skillet; whisk in lemon zest and ginger. Whisk in cream and cook over high heat, stirring constantly until mixture is somewhat reduced and sauce thickens slightly. Stir in apples; heat until apples are just tender and warmed through. Pour over chicken and serve. Makes 4 servings.

Scalloped Potatoes

4 large potatoes, peeled and cut
 into ⅛-inch slices
⅓ cup chopped onion
3 tablespoons butter

4½ teaspoons all-purpose flour
1½ teaspoons salt
⅛ teaspoon black pepper
2 cups milk

Preheat oven to 350°F. Layer potatoes in greased 1½-quart casserole dish. In a medium saucepan, sauté onion in 3 tablespoons butter until tender. Remove from heat; blend in flour, salt, and pepper. Slowly stir in milk. Return to medium heat and cook, stirring constantly, until mixture thickens slightly and comes to a boil. Pour mixture over potatoes. Bake, covered, 30 minutes. Uncover and bake 1 hour longer, or until potatoes are tender. Makes 4 to 6 servings.

Easter Baskets

Marianne Coyne

Chocolate bunnies fill the room
with a scent that makes me swoon
and think of days so long ago
with Easter baskets hidden low.

The bounty of each basket held
our senses captive—quite compelled.
Pastel colored eggs galore,
marshmallow chicks, and so
 much more.

"Just one bite!" we'd plead
 with Mother—
me, my sister, and our brother—
Until she couldn't help but say,
"Alright, my dears, but then away!"

Put on your suit and Sunday dresses;
comb your hair and brush your tresses.
It's time for church—we'll not be late
for Easter praise, to celebrate."

Round about Easter

Marguerite Gode

Round about Eastertime,
quick as a wink,
ribbon grass freshens
and flowers turn pink.
Eggs in their baskets
take on overnight
strangest of colors,
artistically bright.

Round about Easter,
you'll thrill to the stir
of catkins wakening,
starting to purr.
Robins returning
will carol new cheer;
bluebells start ringing—
glad Easter is here.

Bunnies go hippity-
hopping about;
trees in the woodlands
are feathering out.
Children are frolicking,
warmed by the sun.
Round about Eastertime,
isn't it fun?

Image © OkSix/Adobe Stock

The Easter Party
LaVerne P. Larson

The bunnies had a party
in the meadow down the lane,
for the time was drawing near
to color eggs again.

Pulling brightly painted carts
with eggs heaped oh-so-high,
each little bunny set to work
beneath the soft spring sky.

The colors and designs they chose
were dainty as could be;
the loving care with which they toiled
was wonderful to see.

At last their task was finished
and the eggs were stored away
for the bunnies to deliver
with their love on Easter Day.

Where Easter Eggs Grow
Harriet B. Sterling

I've hunted all around about
among the garden rows.
I've looked in every corner,
but what do you suppose?

Though I've asked everybody,
no one seems to know
in what part of the garden
the Easter-egg plant grows.

Little hen, speckled hen,
Eastertide has come again.
Do me a favor, now I beg,
lay me a pretty Easter egg.

Little white rabbits, so they say,
lay bright-colored eggs on Easter Day—
green and purple and red and blue,
I've seen the eggs, so I know 'tis true!

Chocolate Bunny Ears

Andrew L. Luna

Witnessing the excitement my two children experience on Easter morning always rekindles memories of my own childhood Easters, especially my love for chocolate bunny ears.

I recall eagerly jumping out of bed each year to see what the Easter Bunny had brought me. Now, mind you, my basket generally contained the same stuff year after year: jellybeans of assorted colors and flavors, malted milk balls, small milk chocolate eggs wrapped in colorful foil, and marshmallow chicks. Without exception, however, the pinnacle of the Easter basket towered over the other goodies. It was a large, hollow, milk-chocolate bunny with two big ears.

I loved my chocolate friend, with its hard candy eyes, protruding teeth, carved whiskers, and button nose. But the thing I loved most was those long, slender ears. Even though Mom would always warn my sister and me not to spoil our breakfast, I would immediately open the bunny's box, pull it out just enough, and bite off the ears.

After my attack, the only thing left of the rabbit's ears were a few chocolate shards that broke away and fell into the hollow body. The rest of the bunny was too large to bite, so I used my fingers to break off pieces. Frankly, though, the rest of the bunny didn't seem as important to me as the coveted ears.

My carnivorous craving for chocolate bunny ears didn't stop with mine alone. Sometimes I would go after my sister's bunny as well. See, my sister rarely opened her bunny right away, often keeping it for weeks or months, or, in one case, years. For five years, one chocolate bunny sat in her closet and looked down at me with his sneering eyes and long, intact ears. I mean, what is the point of a chocolate bunny if not to eat it? I believed that I had an obligation to bite off her bunny's ears, because she was just going to let them go to waste. I was able to convince myself that a quick bite of the ears would go unnoticed as long as I put her bunny neatly back in the box.

But it never failed that, sometime after dinner, my sister would discover the crime and screech out, "Hey, Mom, Drew bit off my bunny ears again!" All eyes would look at me sternly as I stuffed malted milk balls in my mouth and tried to act innocent.

Now that I am older, my appetite for chocolate bunny ears has waned. I still walk the grocery store aisles at Eastertime with a mischievous grin on my face as I pass the chocolate bunnies, but I leave them to others now. My twins open their boxes immediately each year, pulling out their bunnies just enough to bite off the ears. I smile, knowing the tradition continues.

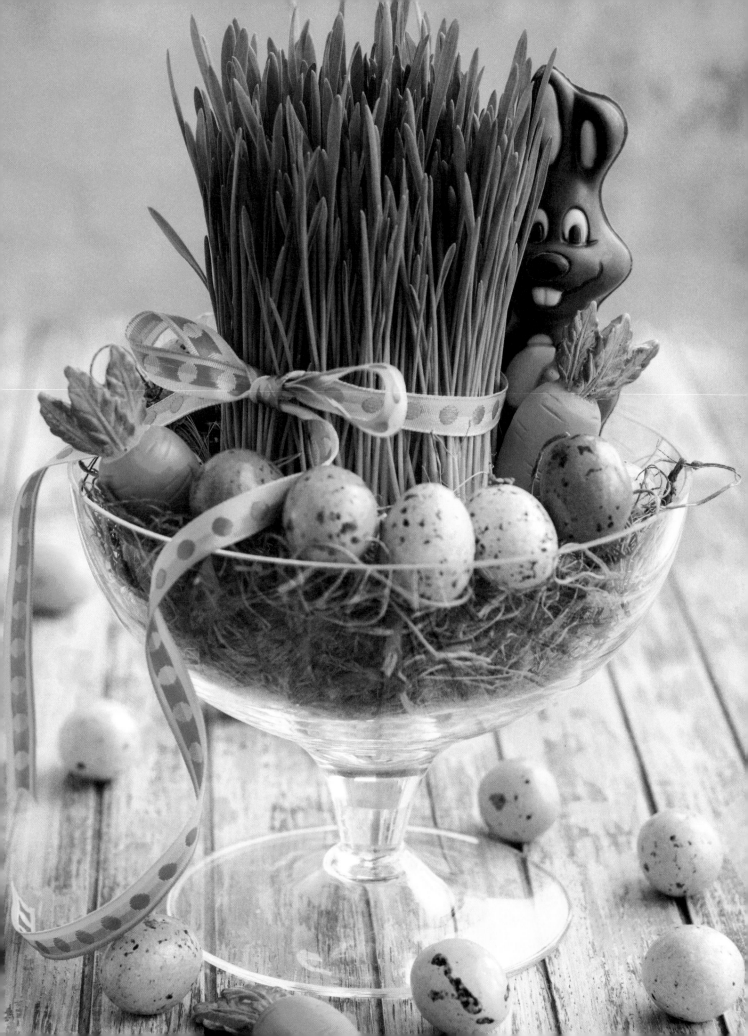

Bits & Pieces

Come, gentle Spring!
Ethereal mildness! Come.
—*James Thomson*

I think of the garden after the rain;
and hope to my heart comes singing,
"At morn the cherry blooms will be white,
and the Easter bells be ringing!"
—*Edna Dean Proctor*

The Infinite has written its name on
the heavens in shining stars, and on
the earth in tender flowers.
—*Jean Paul Richter*

Spring bursts today, for Christ is
risen and all the earth's at play.
—*Christina G. Rossetti*

On this Good Friday may we never forget
the true meaning of Easter—for when He was
on the cross, I was on His mind.
—*Author Unknown*

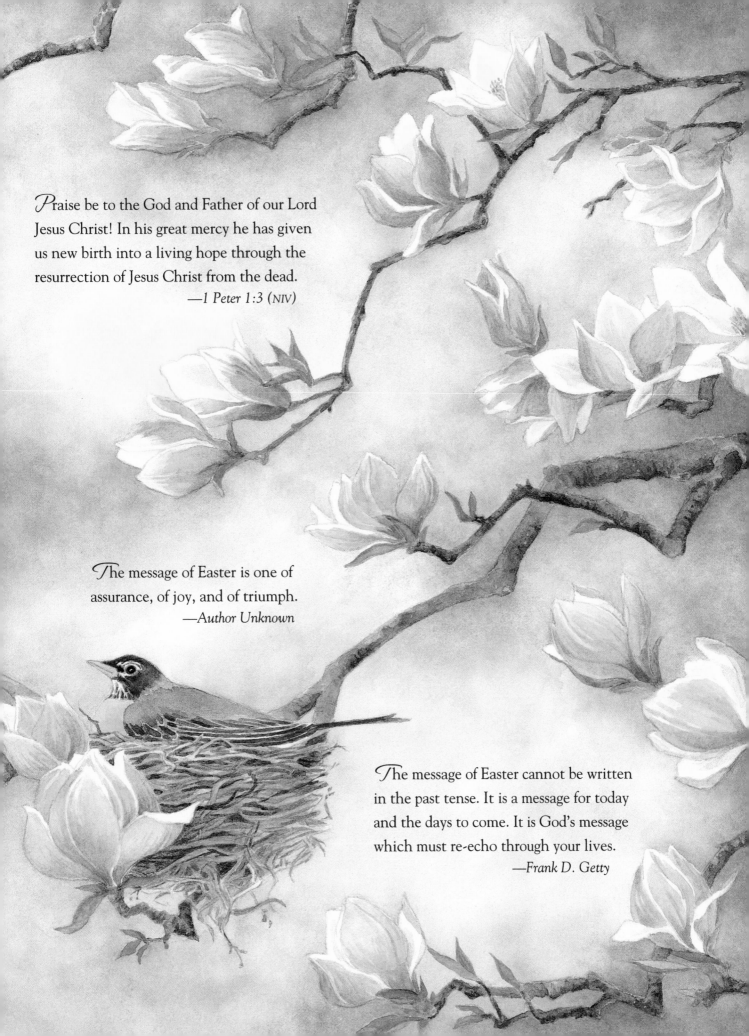

Praise be to the God and Father of our Lord Jesus Christ! In his great mercy he has given us new birth into a living hope through the resurrection of Jesus Christ from the dead.
—1 Peter 1:3 (NIV)

The message of Easter is one of assurance, of joy, and of triumph.
—Author Unknown

The message of Easter cannot be written in the past tense. It is a message for today and the days to come. It is God's message which must re-echo through your lives.
—Frank D. Getty

EXCERPT FROM

April

John Burroughs

Is there anything like a perfect April morning? One hardly knows what the sentiment of it is, but it is something very delicious. It is youth and hope. It is a new earth and a new sky. How the air transmits sounds, and what an awakening, prophetic character all sounds have! The distant barking of a dog, or the lowing of a cow, or the crowing of a cock, seems from out the heart of nature, and to be a call to come forth. The great sun appears to have been reburnished, and there is something in his first glance above the eastern hills, and the way his eye-beams dart right and left and smite the rugged mountains into gold, that quickens the pulse and inspires the heart.

SPRING PASTURES *by Randy Van Beek. Image © Randy Van Beek/Art Licensing*

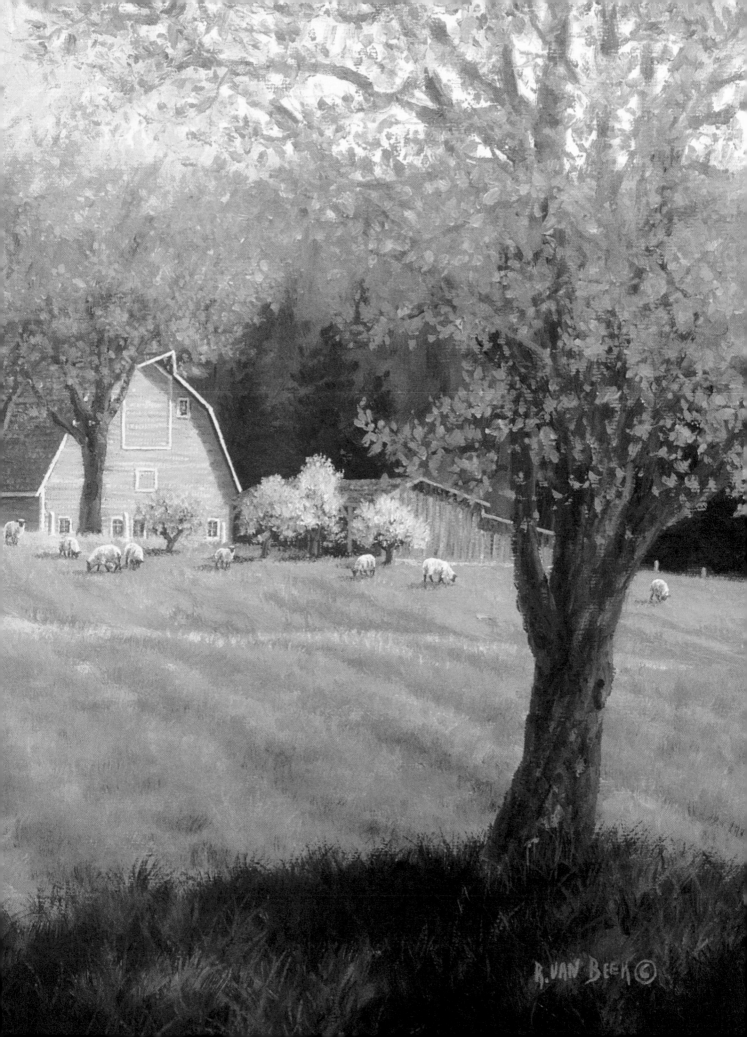

The Pattern of Spring

Mamie Ozburn Odum

Come walk with me through
 Spring's woodland;
note the dappled, shadowed ground;
see the patterns of fine laces
woven with a skill profound.

Golden glints on silver background,
soft as dew on April air;
every movement fits the pattern
for the dress which Spring must wear.

Silver threads with jeweled splendor;
changing shadows mix and cling,
green of jade-pine needles weaving
dainty slippers for Miss Spring.

Listen to the treetops singing;
walk the steep and narrow trail;
see the intricate webbed shadows
mirroring the long, lace veil.

Oh, there's wonder in bright April,
for we know that it will bring
all the flowers for Earth's altar
in the coming of the Spring.

There are singing, sighing, whispers,
in the soft sweet fall of rain,
as the wind in all the treetops
chants and whistles a refrain.

Come watch Miss Spring invade
 the woodland;
listen to anthems of the air,
here in God's outdoor cathedral
waiting for all to share.

The Spring Tea

Clara Brummert

*R*ecently, while I planted petunias in the boxes lining our patio railing, two little girls in frothy tutus enjoyed a tea party on a neighboring porch. I leaned back on my heels and watched for a moment, as one poured tea for the other from a little plastic pot. The sweet scene reminded me of a lovely tea that I attended long ago, on a warm spring day. I was just a young girl, playing alongside Momma, when she set aside her work to have a tea party with me.

That morning, after Momma walked Daddy to the door, she wiped the toast crumbs from my lips and brushed a kiss on my nose. Then, she headed down the hall to begin spring cleaning. I followed along to her room, pushing my teddy bear in a doll stroller.

Humming, Momma took the pillows from her bed and helped me make a bed for Teddy in the corner. She pulled a silk scarf from a drawer, and I covered Teddy as she wound open the window.

The curtains fluttered as the fragrance of honeysuckle drifted in, and Momma began to clean. I giggled when she tickled my toes with the mop, then I sang Teddy a lullaby before using the stroller to ferry my tea set over from the playroom.

After Teddy's nap, I pretended to be a princess, and Momma tied the scarf around my shoulders like a shawl. I fluffed Teddy's bed into a table and daintily sipped air from a little cup as Momma moved her jewel box to the bed so she could wax the dresser.

Suddenly, I needed a necklace to complement my shawl.

With a boost from Momma, I scaled the bed and scooted close to the jewel box. The distant hum of a lawnmower joined my own little song as I gently inspected the necklaces. Grinning, I held each one to my shoulders in front of the mirrored lid.

I finally donned a long pink one before nudging the jewel box toward Momma so she could return it to the dresser.

Instead, she surveyed the sun-filled room, propped her mop in a corner, and held out the folds of her apron and curtsied.

"Will you join me for tea, my lady?" Momma asked as she gracefully swept down.

"Yes!" I blurted. I jumped from the bed and dipped down.

"You'll need a gown." Her smile broadened as she untied her apron strings.

Momma wrapped her apron around my middle and drew the sashes around to the front where she tied them in a bow. I looked down

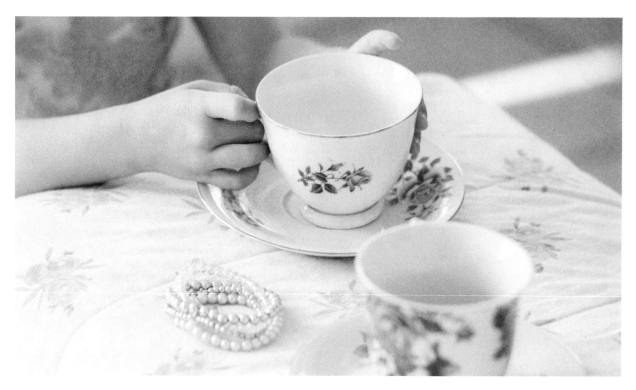

at my toes peeping out beneath the ruffled hem and giggled.

Momma slipped a string of beads over her head. With Teddy in my arm, we promenaded past my plastic tea set on our way to the kitchen, where Momma stood on tiptoes to pull down her best china cups and saucers. She pushed aside the big teapot and brought down the creamer, a dainty pitcher that I could manage without spilling. She filled the pitcher with lemonade.

"Let's pretend it's tea!" I said and clapped while I pranced.

Momma cut a slice of pound cake into morsels, then asked me to arrange our tiny cakes on another china saucer.

The warm porch air smelled of fresh-cut grass as Momma arranged white wicker chairs around a tray table and I shook open a linen napkin to use as a tablecloth. I carried out the pitcher, and Momma followed with the cups and cake, the screen door softly clapping behind her.

I poured our tea as the breeze gently swayed the daffodils and a robin pecked the grass. The sky was the palest of blues, drenched with buttermilk sun. For certain, that day long ago, we were two ladies on a veranda, looking out on a beautiful garden.

Back in the present day, I was pulled suddenly from my reverie when one of the little girls flounced across the yard in her tutu and offered me a cookie. I ruffled her hair and thanked her, and I looked for a moment at my trowel before heading to the hammock to more fully enjoy the gorgeous spring afternoon.

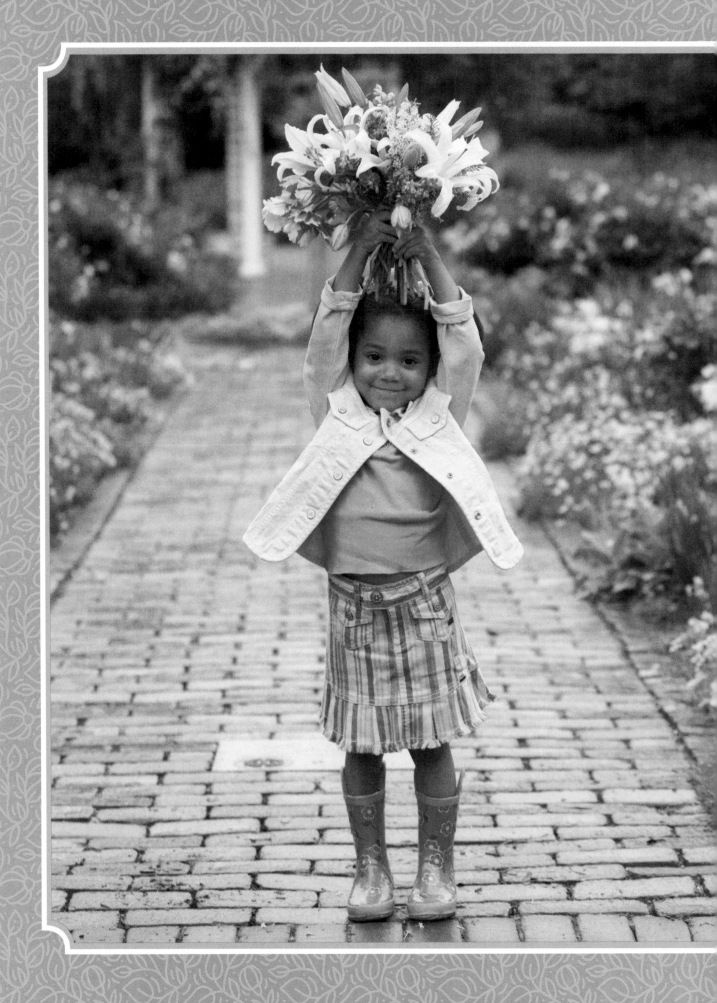

> *"When it rains on your parade, just put on really cute boots."*
> —Author Unknown

Rubber Boots

Rowena Bastin Bennett

Little boots and big boots,
 traveling together
on the shiny sidewalks,
 in the rainy weather;
little boots and big boots,
 oh, it must be fun
to splash the silver raindrops
 about you as you run,
or scatter bits of rainbow
 beneath the April sun!

Big boots and little boots,
 you know how it feels

to have the white clouds
 drifting
 far below your heels;
and it's dizzy pleasure,
 along the way to school,
to walk the lacy treetops
 that lie in every pool.

Little boots and big boots,
 how you like to putter
in every slender streamlet
 that scampers down the
 gutter!

How you like to dabble
 where the current crinkles
and fill the flowing water
 with new and wider wrinkles;
or stir the yellow clay up
 to sudden, cloudy puffs
that dull the shining surface
 with muddy browns or buffs.

Big boots and little boots,
 travel on together,
merrily go splashing
 through April's rainy
 weather!

Rain

P. F. Freeman

I like the kind of rain
that comes without a blow—
the kind that makes the flowers
their prettiest colors show.
I like the soft and quiet way
it falls upon the ground,
just to watch those little raindrops
strike the earth and then rebound.

Praying for Rain

Deborah A. Bennett

The whole world is hushed today, with a quiet so thick it buzzes in my ears like flies in spring. Every footfall and every beating of a blackbird's wing resounds like a roll of thunder. I wander from window to window barefoot and daydreaming about nothing but the maple leaves and yellow marigolds blooming in the yard, and wind chimes on the porch tinkling in the breeze. It is so near Easter and spring, I can see it growing in the forest, the span of a road's length away, where a riot of color and scent stirs and glows greener and greener with leaves and grass and pine needles tinged with the smell of rain.

In my sunny room I feel a sense of peace stirring in my head like the hum of bees, their unbroken vibrations running through the distant fields and hills and valleys like ocean waves. The rain clouds hang gray and still like the paper kites a child would launch from a porch stair, leaping down into the open yard to tug them higher and higher into the sky. A cool breeze is lifting a veil of fog that hung over the valley all night, and a bow of sun is peeking out above the treetops and rooftops, and seems now almost within reach.

At my feet, kittens huddle on a pillow in a wicker basket, and are the perfect accompaniment to the wordless poetry of wind and rain and birdsong. On my lap a steaming bowl of chicken noodle soup wraps around my solitude like a warm blanket, and an old book waits patiently at my side to take me to another world. I take one sip, then another, letting the salt and spices lull me into that familiar contentment I remember from childhood's Easter days when the steady drumbeat of rain joined the blue and red and brown birds singing in the budding tree branches, sending throaty, warbling calls into the silver water pooling beneath the thick green hedges wrapping round the yard.

The gold sun's peeking in and out of the shadows of clouds, as beside the open window, I close my eyes, sharing the serenity of the kittens, simply waiting on a pillow for the world to turn. I nestle my fingers in the soft bundle of ginger fur, on the full, round bellies, and the tiny paws spread wide in the air, the feathery bleating rising, then falling softly inside the basket's edge.

There would not have been time to be this still on any other day. Even on the rare day off from work, there would have been work to do. The lawn to mow, the hedges to trim, the garden to plow and pet. There are some days I long for nothing to do but be in the moment, with nothing to accomplish, like a child at Easter again. Curled up with a book, or a basket of cats, sleeping on the windowsill. There are some days I pray for rain.

Kite-Making Time

Johnielu Barber Bradford

Without a calendar, I know
spring days are surely in sight—
young hands are busy collecting
materials to make a kite!

Spring winds have also informed me,
but there is a far better sign—
I saw three lads assembling
small sticks, some paper, and twine.

Their project was soon completed:
a kite with its long gingham tail
and a ball of knotty string
to guide their beautiful sail.

Give a boy a high windy hill,
place a kite he made in his hands—
you can see his spirit take wings
in a dream that he commands.

Kite-Flying Time

Jean Adams

There's always a day each spring
when the wind is racing and free,
the trees are green, there's a nip in the air—
that is kite-flying time to me.

Remember the tug of the string,
insistent and pulling so tight,
remember the faraway diamond
up in the sky—your kite?

The wind would buffet, your arms would ache
but that couldn't even compare
to the thought that you were part of
the freest kite in the air.

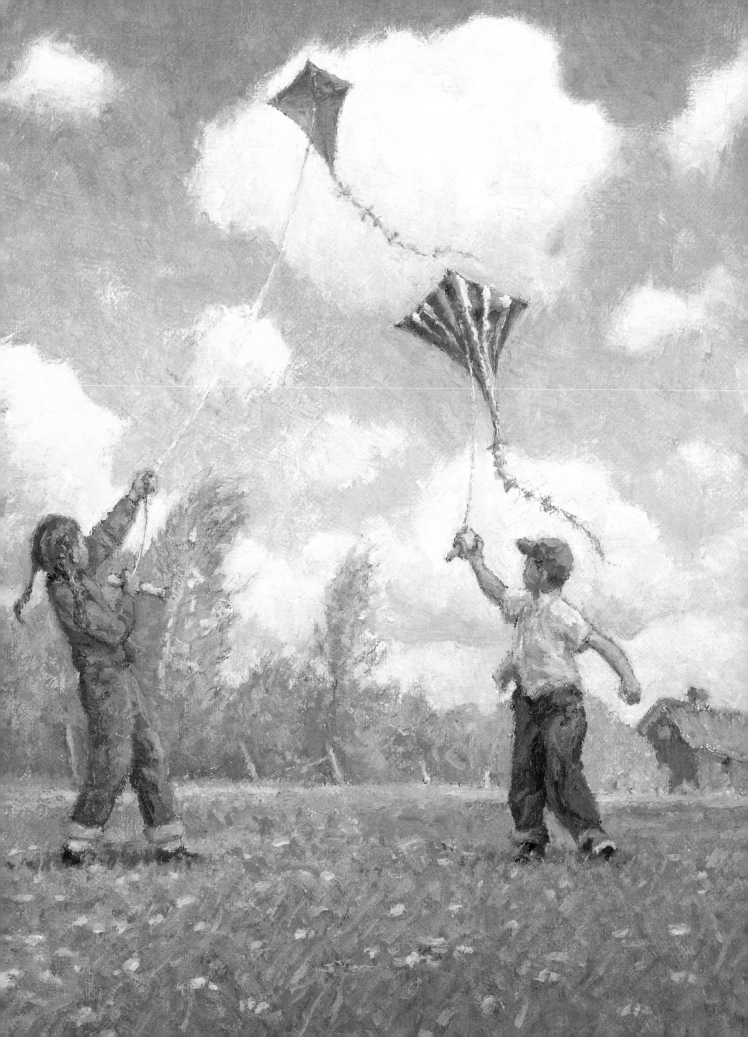

Dandelions
Frances Ellen Watkins Harper

Welcome, children of the
 spring,
in your garbs of green and gold,
lifting up your sun-crowned
 heads
on the verdant plain and wold.

As a bright and joyous troop
from the breast of earth ye came;
fair and lovely are your cheeks,
with sun-kisses all aflame.

In the dusty streets and lanes,
where the lowly children play,

there as gentle friends ye smile,
making brighter life's highway.

Dewdrops and the morning sun
weave your garments fair and
 bright,
and we welcome you today
as the children of the light.

Children of the earth and sun,
we are slow to understand
all the richness of the gifts
flowing from our Father's hand.

Signs of Springtime
Helena K. Stefanski

Bobby burst into the kitchen
before the front gate closed,
astonishing his mother
and the kittens that
 had dozed.

"It's spring! It's spring!"
 he shouted,

"Our barn swallows are here,
chirping loud and noisy
by the nest they built last year!"

Then with no more discussion
(for he had no time to lose)
prepared himself for springtime
by taking off his shoes.

Resurrection

Emily May Young

The promise of resurrection
is not only told in the Book;
it is heralded in the springtime
by every gurgling brook.

It is announced by violets
and by the dogwood trees.
It is chanted by the
mockingbird
and the buzzing of the bees.

It is echoed every Easter
by the lily's perfumed breath,
when every sleeping plant awakes,
triumphant over death.

ISBN: 978-1-5460-3431-5

Published by Ideals
Hachette Book Group
1290 Avenue of the Americas
New York, NY 10104

Printed and bound in the U.S.A.

Publisher, Peggy Schaefer
Senior Editor, Melinda Rathjen
Designer, Marisa Jackson
Associate Editor & Permissions, Kristi Breeden
Copy Editors, Amanda Varian, Abigail Skinner

Cover: Picket Fence *Bouquet* by Abraham Hunter. Image © Abraham Hunter/MHS Licensing
Inside front cover: *Spring in Garden Room* by Kim Jacobs. Image © Kim Jacobs/Art Licensing
Inside back cover: *At Home in Cotignac* by Kim Jacobs. Image © Kim Jacobs/Art Licensing

Additional art credits: art for title page, back cover, and "Bits & Pieces" by Linda Weller.

Want more homey philosophy, poetry, inspiration, and art? Be sure to look for our annual issue of *Christmas Ideals* at your favorite store.

Join a community of *Ideals* readers on Facebook at: www.facebook.com/IdealsMagazine

Readers are invited to submit original poetry and prose for possible use in future publications. Please send no more than four typed submissions to: Hachette Book Group, Attn: *Ideals* Submissions, 6100 Tower Circle, Suite 210, Franklin, Tennessee 37067. Editors cannot guarantee your material will be used, but we will contact you if we do wish to publish.

ACKNOWLEDGMENTS

BEDFORD, FAITH ANDREWS. "Sister Dresses" Copyright © 2005 by Faith Andrews Bedford, www.faithandrewsbedford.com. All rights reserved. Used by permission. OUR THANKS to the following authors or their heirs for permission granted or for material submitted for publication: Jean Adams, Rowena Bastin Bennett, Deborah A. Bennett, Johnielu Barber Bradford, Anne Kennedy Brady, Clara Brummert, Marianne Coyne, Grace Noll Crowell, Joan Donaldson, P. F. Freeman, Marguerite Gode, Edgar A. Guest, M. Kathleen Haley, M. Aileen Hancock, Clay Harrison, Marilyn Jansen, Pamela Kennedy, Minnie Klemme, LaVerne P. Larson, Pamela Love, Andrew L. Luna, John Richard Moreland, Mamie Ozburn Odum, Garnett Ann Schultz, Mildred Musgrave Shartle, Eileen Spinelli, Helena K. Stefanski, Lorna Volk, Emily May Young.

Scripture quotations, unless otherwise indicated, are taken from the King James Version (KJV). Scripture quotation marked BSB taken from *The Holy Bible, Berean Study Bible*. Copyright © 2016, 2018 by Bible Hub. Used by permission. All rights reserved. Scripture quotations marked NIV taken from the *Holy Bible, New International Version®*, NIV®. Copyright © 1973, 1978, 1984, 2011 by Biblica, Inc.™ Used by permission of Zondervan. All rights reserved worldwide. www.zondervan.com. The "NIV" and "New International Version" are trademarks registered in the United States Patent and Trademark Office by Biblica, Inc.™

Every effort has been made to establish ownership and use of each selection in this book. If contacted, the publisher will be pleased to rectify any inadvertent errors or omissions in subsequent editions.